Master Paintings from The Phillips Collection, *Washington*

HAYWARD GALLERY, LONDON
19 MAY – 14 AUGUST 1988

SOUTH BANK CENTRE

HAYWARD GALLERY, LONDON
19 MAY – 14 AUGUST 1988

Following the London showing the exhibition will travel to the Schirn
Kunsthalle Frankfurt and the Centro del Arte Reina Sofia, Madrid.

Exhibition organised by the South Bank Centre

Exhibition organiser: Catherine Lampert
Exhibition assistant: Rosalie Cass

Catalogue published by the South Bank Centre

ISBN 1 85332 022 6

A full list of all South Bank Centre and Arts Council exhibition
publications may be obtained from the Publications Office, South
Bank Centre, Royal Festival Hall, London SE1 8XX.

Designed by Tim Harvey
Printed by Lecturis, Eindhoven

Cover: Detail from Renoir's *The Luncheon of the Boating Party* 1881

Photographic acknowledgements: Harry Connolly and Dennis Kan

Foreword

As long as eight years ago the Arts Council discussed the possibility of a selection of works from The Phillips Collection coming to London. The collection was already known as a generous lender to our exhibitions and as a place where visitors to Washington had the memorable experience of seeing what the founder Duncan Phillips called 'a museum of modern art and its sources' in the sympathetic surroundings of rooms which were originally the family's private house. We were delighted when Laughlin Phillips offered the present exhibition, a selection of seventy-five masterpieces, following its Australian tour. The Collection generously agreed to add sixteen works including several by contemporary painters.

We would like to express our thanks to Mr Phillips and to his staff for their enthusiasm and painstaking assistance in preparing the exhibition and this catalogue.

We are extremely grateful to Sir Lawrence Gowing, Curatorial Chairman at The Phillips Collection, for his introduction and appreciation of the taste and vision of Duncan Phillips; and to the British art historian Penelope Curtis who, at short notice, prepared biographical notes on the artists.

For generous financial support we are indebted to Merrill Lynch and Co., Inc., who have made possible the world tour and to Grand Metropolitan PLC who have sponsored the exhibition in London.

Joanna Drew
DIRECTOR OF EXHIBITIONS

Catherine Lampert
EXHIBITION ORGANISER

Preface

I am delighted that this strong selection of paintings from The Phillips Collection will be seen by large audiences in London, Frankfurt, and Madrid. Although well known among arts professionals throughout the world, the Collection for many years maintained a low public profile and has only begun in recent times to achieve the sort of general recognition appropriate to the quality of its holdings.

The catalogue introduction which follows tells the story of how my father, Duncan Phillips, decided in 1918 to share his pleasure in art by creating a public art museum in part of his family home in Washington. Starting with very limited family holdings, he and his wife, the artist Marjorie Phillips, rapidly built the Collection into an outstanding museum of modern art. By the time of his death in 1966, Duncan Phillips had given the museum over two thousand paintings, the two buildings which it now occupies, all of its operating expenses over a forty-eight year period, and an endowment which he hoped would provide for its future.

Soon after becoming director of the museum in 1972, I became preoccupied with the problem of ensuring the physical and financial security of an art collection which is widely regarded as one of our national treasures. Since neither the endowment nor the Phillips family could in these times provide the level of support required for the proper management of such a museum, I have worked with our trustees to provide it with a broader base of public support by organising travelling exhibitions of some of its finest works. The first of these exhibitions, entitled *Impressionism and the Modern Vision: Master Paintings from the Phillips Collection*, toured six American cities, as well as two Japanese cities, in 1981-83. The present exhibition has been planned to coincide with the renovation and enlargement of one of our buildings, so that for the first time the museum will have safe and adequate spaces for the storage and handling of its works of art. It began its world tour in Australia in 1987, with stops in Canberra, Perth, and Adelaide.

All of us at The Phillips Collection are very grateful to the distinguished institutions which are participating in the European segment of the tour and to their representatives who have so effectively assisted in its organisation. Among these for the Hayward Gallery, are Ronald Grierson, Executive Chairman, South Bank Board and Catherine Lampert, Exhibition Organiser; for the Schirn Kunsthalle in Frankfurt its director Dr. Christoph Vitali; and for the Reina Sofia in Madrid, Miguel Satrustegui, Director General of Fine Arts and Archives of the Ministry of Culture, Carmen Jimenez, Director of Exhibitions of the Ministry of Culture, and Ana Beristain, Chief Conservator Department of International Art.

Finally, we are very grateful to Merrill Lynch & Co., Inc., for the sponsorship which made the world tour possible.

Laughlin Phillips, DIRECTOR
The Phillips Collection

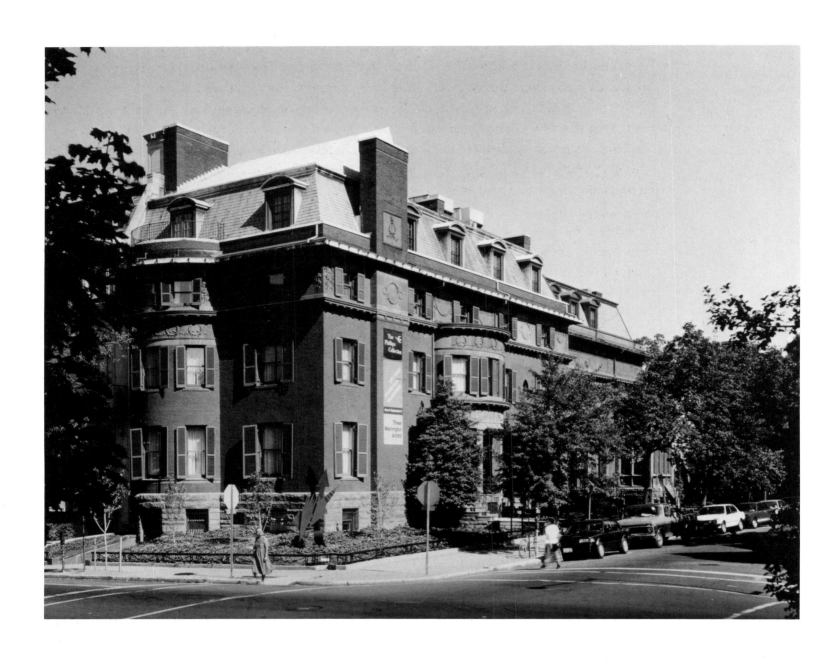

The Phillips Collection, located off Embassy Row in the Dupont Circle neighbourhood of Washington.
photo: © 1985 Lautman Photography, Washington

Master Paintings from The Phillips Collection, Washington

Anyone who looks at early modern painting knows of The Phillips Collection. That is to say, almost anyone who looks at painting. The beginnings of Modernism, Post-Impressionism as they used to be called, are now generally accepted as central to our understanding of the visual arts. They are the axis round which a concern with the arts still revolves. Whoever revolves with it becomes accustomed to having the name of the Collection in the corner of his eye whenever he consults illustrations of favourite pictures. It is credited under the countless reproductions of what is surely Renoir's master-piece. It accompanies six great Cézannes and two of the most attractive Arles Van Goghs. It is inseparable from the two pictures by Matisse, two cornerstones of the triumphant edifice of his career. And so on; well-known pictures, which are staple fare for any appetite for painting and also numerous pictures that are better than that, pictures that were peaks of achievement in the early modern age. Pictures great enough never to exhaust their meaning; great enough not willingly to be relinquished from the resource on which a serious idea of painting depends. Tucked away as they are in the grand streets where embassies cluster in the District of Columbia, they never become too familiar, never quite lose their power to surprise us.

Those who arrive at the classic building on Twenty-First Street, finding it as likely as not in one of its habitual phases of reconstruction, discover that The Phillips Collection is something rather more than, and different from, the sum of its contents. If visitors have taken the noted Collec-tion for granted, one can promise that they will never do so again when they have seen it *in situ*. Quite apart from the surprising beauty of picture after picture, visitors find themselves in an unac-customed kind of museum with an unforeseen focus. It is a museum of convictions, an anthology of the personal uses for art. There are furnishings and ninety-ish fireplaces; one might at first think one was visiting a collection of historic interiors. But it is not that; the pictures are too good. The furni-ture is too various. The atmosphere is relaxed and friendly, rather than stylish. We realize that we are looking at painting as a way of life and deducing the story of an ideal family that gathered in this very building round a remarkable man. A family that saw life in terms of art.

The building and its contents share a welcoming humanity. At one moment the architects installed a noble portal leading to the panelled gallery, but it seems not to have been used for long. Visitors come in by the family entrance, as if they were part of the life of the house, as if the family welcomed them – and so it did and does. There is a human normality, rather unlike the grand imper-sonality of a museum, which the beginnings of the Collection go some way to account for. The first and second decades of the twentieth century were the golden age of American collecting, when a considerable part of fortunes like those of Morgan, Altman and Frick were being invested in great masterpieces. In Washington the close-knit family of a Civil War major, who had retired from the manufacture of window-glass, had lately become interested in current American painting. At the beginning of 1916, the two sons, Jim Phillips, a young merchant banker, and his frail, idealistic brother, Duncan, persuaded their parents to devote annually 'a small part of their income', $10,000, to collecting under their guidance.

But two years later the devoted Duncan was prostrated by the deaths in quick succession of

both his father and his lately-married brother. Duncan's way of recovering from the loss was to make plans for using the growing collection, including some twenty pictures which the family brought with it from Pittsburgh when it moved to the milder climate of Washington, as the nucleus of 'The Phillips Memorial Art Gallery', a public museum founded in their honour, 'a memorial', as he called it, 'worthy of the virile spirits of my best leaders'.

The Phillips Collection was in fact generated by a conjunction of the ideal of 'life-enhancement' (at Yale Duncan Phillips had absorbed Pater) with the consolation of 'the emotional gift offered by art . . . its escape from the boundaries of the self.' One cannot be sure when the public purpose supervened. The wing with the spacious panelled library, which was added to the Washington house in 1907, can hardly have been intended for exclusively private use, and the family must always have been animated by some ideal of public service. Suggesting that his parents set aside money for their sons to collect with, Jim Phillips pointed out in 1916 that the wall space at Twenty-First Street was already filled with pictures. His proposal thus implied a request for more space for art and the family proceeded to plan without delay a sky-lit gallery and storeroom above the library, which were built in 1920. Bereavement seems to have encouraged aspirations that Duncan was already cherishing.

One of the earliest acquisitions, a *Turkish Café* by Decamps purchased in 1915, is among the pictures that a visitor still sees first. Within four years the Collection was substantial enough for its public standing to be undeniable. In 1920 it was incorporated in the District of Columbia, and it opened to the public in the family mansion with a notable absence of fuss in the following year. Duncan's resolution was further supported by his marriage in 1921 to Marjorie Acker, a young painter who shared his purpose and his delight.

Duncan Phillips set a tremendous pace. When the Collection was ready to be installed in the home that he continued to share with it, it numbered nearly 250 pictures. At the beginning the Collection was firmly based on his confidence in contemporary American painting. In 1917 and the years that followed there was an understandable element of nationalism in the viewpoint. Explaining his intention in 1920 Duncan wrote: 'Our most enthusiastic purpose would seek to reveal the richness of art created in our own United States and to stimulate our native artists and afford them encouragement and inspiration.' Modern painting in Europe was only gradually assimilated to his faith in American painting. The scope of the Collection in fact broadened continually, in regard to period as well as to place. In 1920 one of the first purchases was a characteristic Chardin. The historical perspective was indispensable; Duncan Phillips did not at first welcome the disconcerting sequels to Impressionism. Essentially the ideal was timeless. The broadening of scope was dramatic; to begin with Phillips knew no limitations whatever. In the early 1920's he was thinking of a long, low building in a Palladian or Colonial style which was to shelter every expressive medium under the sun, literature, performance, music, everything, together with a yearbook in two volumes entitled 'The Herald of Art'. 'There is but one way to bring scattered communities together, to consolidate their most inspired ideas and to unite their most generous impulses, and that is by way of the printed word, that ancient medium of exchange, The Book . . . a book for all the arts even as The Phillips Memorial Art Gallery is to be a home for all the arts . . . Our plans for the unique and intimate gallery are yet in a plastic state. Much depends on the encouragement and support of the American people'. The Collection was no more than a part of his extending ambitions. It signalized an idea of art which was only incidentally modern. Essentially it was perennial and universal, demonstrating

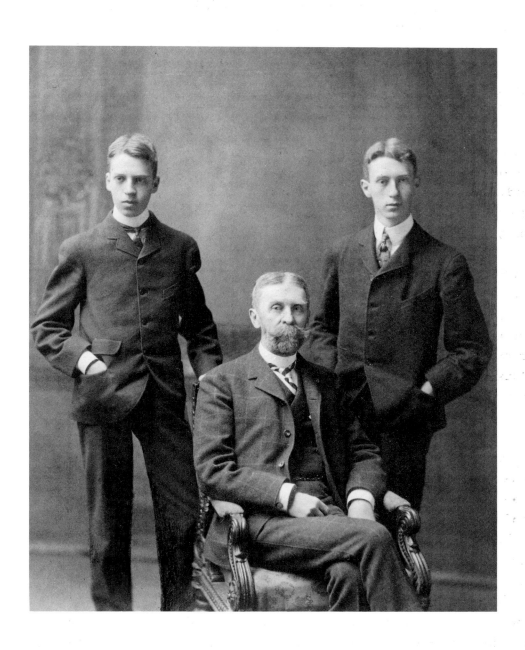

Major Duncan Clinch Phillips (centre) with his sons Duncan (left) and James (right).
photo: undated, probably taken at the turn of the century

both the antiquity of modern ideas and the modernity of selected artists back through time. This is the doctrine on which Duncan Phillips agreed with the critic whom he admired most, Henri Focillon – the idea of art as a universal language irrespective of chronology or geography, the idea of absolute equivalents in form for feeling which descended (as the Collection curator of 19th Century art, Robert Cafritz, has pointed out) from Symbolism. This is the doctrine that artists, as they develop, reveal themselves to have more and more in common with like-minded masters across the ages. The idea of perennial and perpetual modernism was itself the product of its epoch and may seem to bear the marks of its date. The belief that great artists, as they develop, become more and more alike, can perhaps be confirmed in a minority of cases, but more generally it seems to be the exact reverse of what happens. As artists in the Western mode develop to full stature they seem to get less and less like anyone but themselves. Each of them is *sui generis*; even the use of a common tradition is unique. The Rafaelism of Ingres was profoundly unlike the Rafaelism of Poussin; even Delacroix and Rubens were alike only in superficial, imitable respects. The idea of art and its universal language evidently transcended contemporaneity and topicality. If Duncan Phillips thought of Chardin as central to that idea he must have had in mind a broader conception than his purchases so far had suggested. Possibly he was already thinking of the idea of creative domesticity which bore such fruit in the decades to come. With Chardin Duncan Phillips was biding his time. He waited 19 years for a Cézanne still-life, which eventually reached the Collection in a magnificent example that was a gift from his nephew, Gifford Phillips, in commemoration of Jim Phillips, Gifford's father, and the virtual initiator of the family's Collection. Duncan's sense of the timeless unity of art remains compelling to this day. The echoes of Chardin in the 20th century have been epitomized this year in the bequest of a Bonnard, another such collocation of porcelain and heaped-up fruit, which will hang as an ideal pendant to the Chardin and a fulfillment of Duncan's inspiration in 1920.

In 1923 Joseph Durand-Ruel seated Mr. and Mrs. Phillips at lunch opposite the *Déjeuner des Canotiers* – 'that fabulous, incredibly entrancing, utterly alive and beguiling Renoir masterpiece', as Marjorie wrote – and the possibilities of a social genre painting, with all the sensuous humanity that Impressionism was capable of, captivated them at once. It was and is quite irresistible, and seems in retrospect not unreasonable at $125,000; they never paid so much for another picture. The presence of the *Boating Party* at the heart of the Collection has established for good both the humane beauties that tell most in the context of the gallery and the response that Mr. and Mrs. Phillips and their public consistently henceforward brought to art. The amenities of the original gallery – the graceful lightness of the furniture and a corresponding alertness in the sensitivity to art – opened and, as I think, open still, fresh dimensions to the pictures and to the visitors that now come to The Phillips Collection.

Two years later, at another great Paris dealer, Bernheim-Jeune, Duncan Phillips saw a picture of a woman with a dog which Pierre Bonnard had consigned to the firm two years before; it was almost as significant a discovery for the future of the Collection. The woman with the dog was followed by the great series of Bonnards which displayed the domestic dimension of the Phillips view as well as anything Phillips ever bought. The melting glances that Renoir's men and women exchange are no more full of love than the quiet rapture of the relationship of Bonnard's people with his world. Phillips was well aware of the place that Bonnard occupied in his view of painting and so was the painter himself. There is no collection in which Bonnard means so much as he does at the Phillips – nowhere, that is to say, where the domestic view of art is so evidently conclusive and

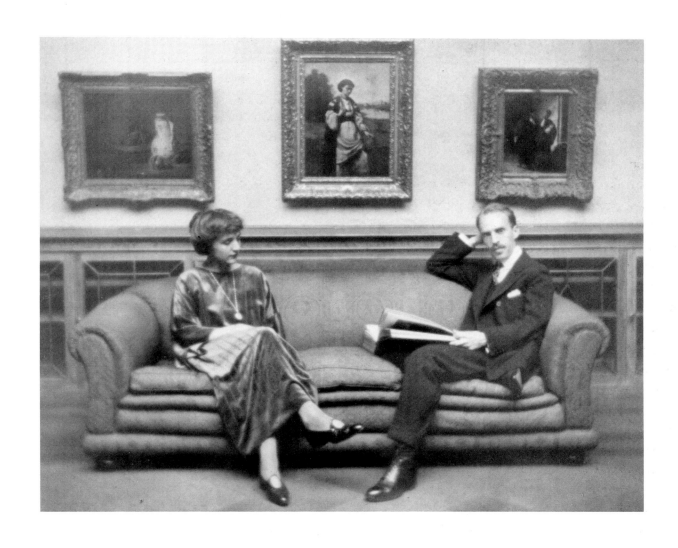

Marjorie and Duncan Phillips in the Main Gallery of The Phillips Memorial Gallery,
as it was then called, c. 1922. photo: by Clara Sipprel

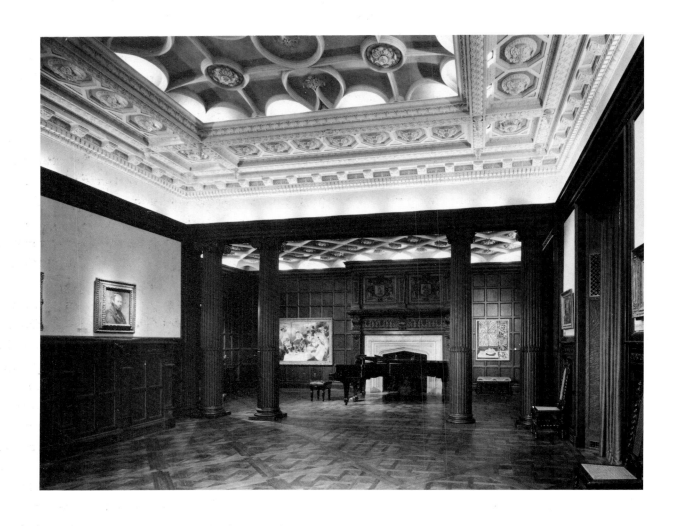

The Music Room of The Phillips Collection.
photo: © 1984 Lautman Photography, Washington

comprehensive. In the Phillips context a majority of his pictures look like masterpieces; there the dappled irridescence is seen to be the living breath of pictorial life. The pearly penumbra that girdles a landscape like *The Palm* is more exquisite at the Phillips than anywhere. Yet perhaps it is at table with Marthe Bonnard and her dog, or by the open window with her cat, that we are nearest to the dimension of feeling that a family and a collection offer to their visitors.

In 1925 the American painter Arthur Dove painted two informal and apparently unpremeditated landscape abstractions called *Golden Storm* and *Waterfall*, which Duncan Phillips acquired in 1926 and which seem to represent a crucial stage in his adjustment to the liberated lyricism of the new American painting Dove converted Phillips to the informality of modern art. More, he seems to have established for the growing Phillips public the possibility of lyrical impromptu as an order of painted expression which was quite distinct from the international canons of modernity dependent on the legacy of Cubism. Duncan Phillips had largely avoided the deliberate structuring and fragmentation which were accounted modern by the cosmopolitan avant-garde. His idea of what was modern was neither polemical nor provocative. It places a premium on solutions that were by contrast either decorative and patterned or evocative and poetic. (It is noteworthy, however, that in 1953 when Marcel Duchamp, as executor of Katherine Dreier's estate, chose to offer the paintings in her estate to The Phillips Collection, Duncan Phillips was quick to accept a selection of fine modern works representing more extreme artistic solutions.)

Similarly, in the tradition of Dadaism and Surrealism he sought out for himself hardly more than a single picture, Miró's comically ominous yet reassuring *Red Sun*, which the Phillips context again announces a masterpiece. The succession of pictures by Bonnard that were added to the Collection in 1926, 1927, 1928 and the years that followed speak plainly of Phillips's understanding of the enlargement for the scope of art that a very private painter and an entirely domestic collection together encompassed. The legacy of Cubism enriched the Collection chiefly in the patterning it offered; at its conclusion in Braque's *Storm* it was lyrical again. Nobody could take the measure of Picasso in this selection and the comparison of El Greco with *The Blue Room*, the kind of comparison that Duncan Phillips delighted in, reveals rather little of the specific genius of either artist. But Phillips's instinct was always better than his theory and the enlargement that he still offers in the meanings of art is more personal, more felt, than any other anthology I know can afford. Many young painters, passing through the capital, have learned in the Collection the best lessons of their lives. At least one of them, Richard Diebenkorn, has credited it with an effect on the results that are now represented in the Collection itself. It is for us to ensure that the uniquely personal generosity of this enrichment of art and the life it serves is continued and perpetuated. Enjoy these masterpieces wherever you see them, but do not suppose that you have seen The Phillips Collection anywhere except on Twenty-First Street.

Lawrence Gowing

ALEXANDER ARCHIPENKO

MILTON AVERY

FRANCIS BACON

GEORGE BELLOWS

PIERRE BONNARD

GEORGES BRAQUE

PAUL CÉZANNE

JEAN-BAPTISTE SIMÉON CHARDIN

WILLIAM MERRITT CHASE

JEAN-BAPTISTE-CAMILLE COROT

GUSTAVE COURBET

HONORÉ DAUMIER

STUART DAVIS

ROGER DE LA FRESNAYE

NICOLAS DE STAËL

HILAIRE-GERMAIN-EDGAR DEGAS

FERDINAND-VICTOR-EUGÈNE DELACROIX

ANDRÉ DERAIN

RICHARD DIEBENKORN

ARTHUR G. DOVE

RAOUL DUFY

(DOMENIKOS THEOTOKOPOULOS) EL GRECO

SAM FRANCIS

FRANCISCO JOSÉ DE GOYA Y LUCIENTES

JOHN D. GRAHAM

JUAN GRIS

PHILIP GUSTON

MARSDEN HARTLEY

WINSLOW HOMER

EDWARD HOPPER

JEAN-AUGUSTE-DOMINIQUE INGRES

WASSILY KANDINSKY

PAUL KLEE

KARL KNATHS

OSKAR KOKOSCHKA

WALT KUHN

GEORGE LUKS

EDOUARD MANET

FRANZ MARC

JOHN MARIN

HENRI MATISSE

JOAN MIRÓ

AMEDEO MODIGLIANI

PIET MONDRIAN

CLAUDE MONET

ADOLPHE MONTICELLI

GIORGIO MORANDI

BERTHE MORISOT

GEORGIA O'KEEFFE

PABLO PICASSO

MAURICE PRENDERGAST

PIERRE PUVIS DE CHAVANNES

ODILON REDON

PIERRE-AUGUSTE RENOIR

MARK ROTHKO

GEORGES ROUAULT

HENRI ROUSSEAU

KER-XAVIER ROUSSEL

ALBERT PINKHAM RYDER

KURT SCHWITTERS

SEAN SCULLY

GEORGES SEURAT

ALFRED SISLEY

JOHN SLOAN

CHAIM SOUTINE

FRANK STELLA

MAURICE UTRILLO

VINCENT VAN GOGH

EDOUARD VUILLARD

JOHN WALKER

I

(Domenikos Theotokopoulos) El Greco
The Repentant Peter c. 1600
oil on canvas
93.6 x 75.2 cm
Guillermo de Guillén Garcia, Barcelona; Ignacio Zuloaga, Zumaya;
Ivan Stchoukine, 1908; Heilbuth Collection, Copenhagen, 1920;
acquired through The Ehrich Galleries, New York, 1922.

Measurements are given in centimetres, height x width

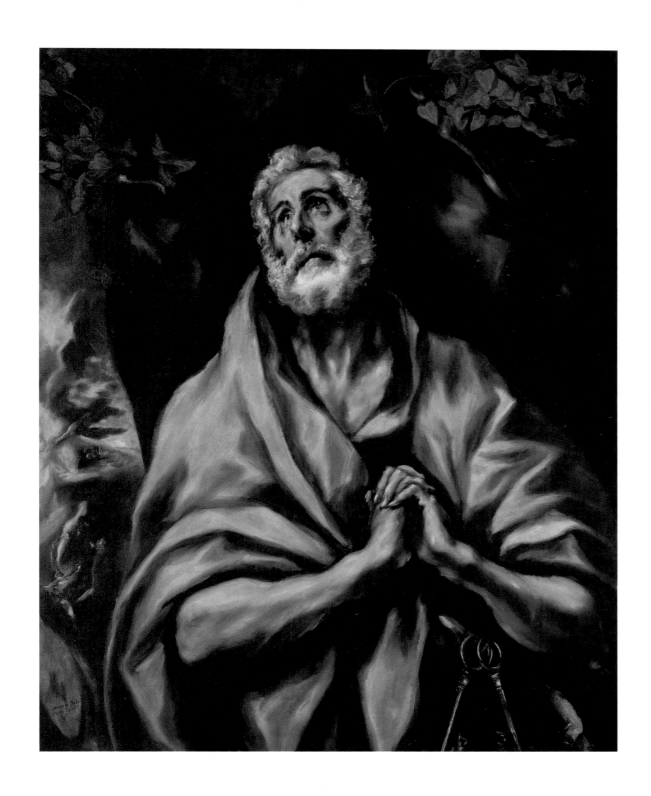

2

JEAN-BAPTISTE SIMÉON CHARDIN

A Bowl of Plums c. 1728

oil on canvas

45 x 56.8 cm

Roberts Collection, London; acquired through Wildenstein & Co.,

New York, 1920.

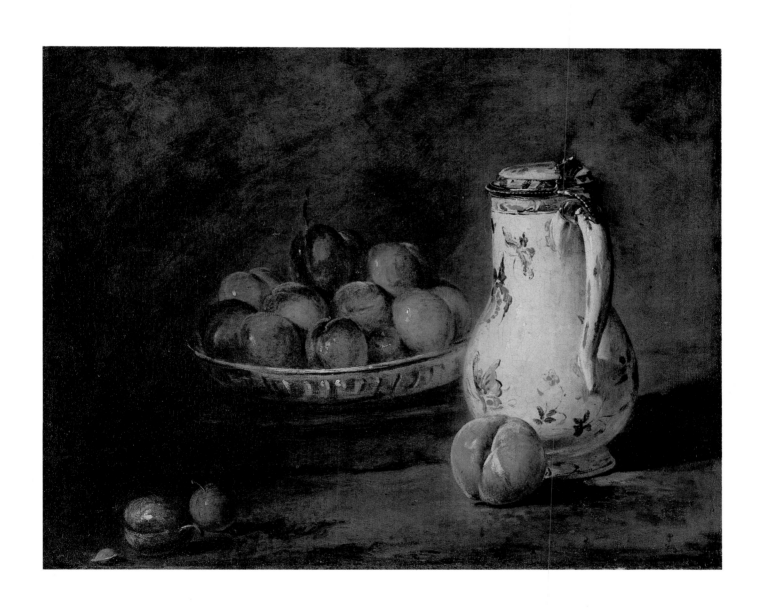

3

FRANCISCO JOSÉ DE GOYA
Repentant Peter c. 1820-24

oil on canvas

73.3 x 64.7 cm

Don Alejandro Pidal, Madrid; Duc de Trévise, Paris; acquired through
Newhouse Galleries, New York, 1936.

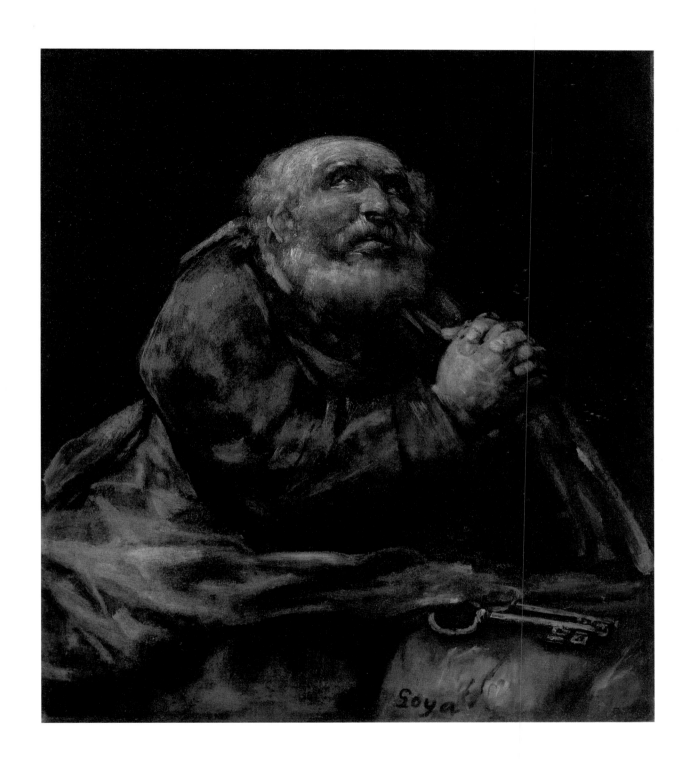

4

JEAN-BAPTISTE-CAMILLE COROT

View from the Farnese Gardens, Rome 1826

oil on paper mounted on canvas

24.7 x 40.3 cm

Posthumous Corot sale, 1881, to M. Detrimont, Paris; Quincy Adams
Shaw Collection, Boston; Mrs Malcolm Graeme Houghton; acquired
through Paul Rosenberg & Co., New York, 1942.

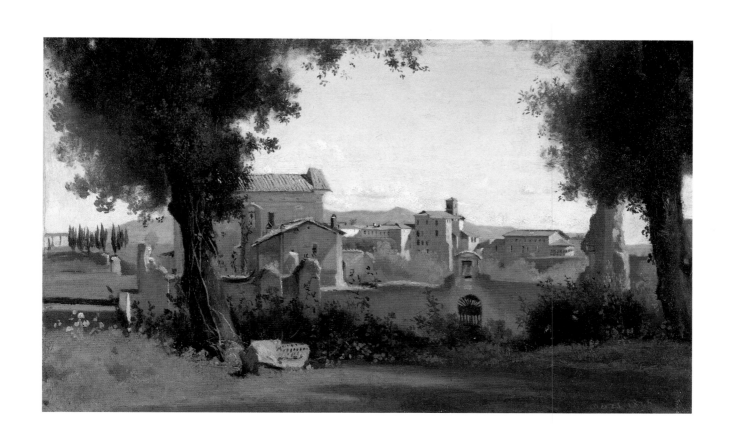

5

JEAN-AUGUSTE-DOMINIQUE INGRES
The Small Bather 1826

oil on canvas

32.7 x 25 cm

E. Blanc until 1962; Mme Blanc; Haro;

Baron Moure sale, 1892;

Paul Rosenberg & Co., Paris, to Baron Françoise de Hatvany, ca. 1911;

Paul Rosenberg & Co., 1947; acquired from Paul Rosenberg & Co.,

New York, 1948.

6

JEAN-BAPTISTE-CAMILLE COROT

Genzano 1843

oil on canvas

35.8 x 57.1 cm

(LONDON ONLY)

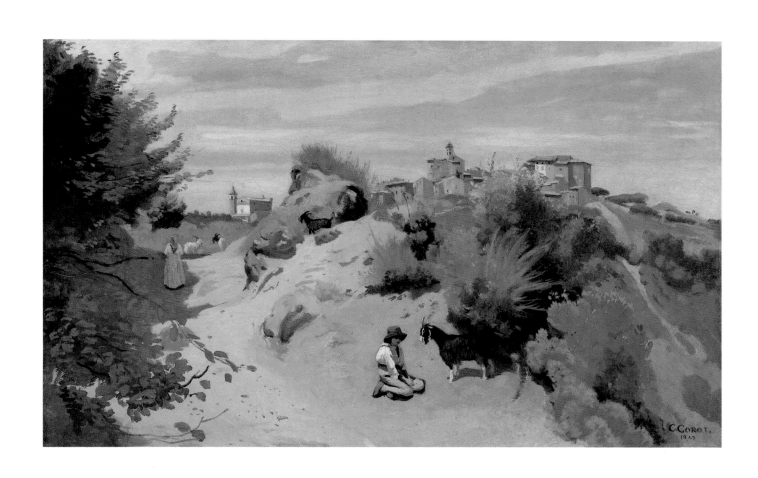

7

GUSTAVE COURBET

Rocks at Mouthier c. 1850

oil on canvas

77.4 x 117.8 cm

Félix Gérard, senior, estate sale, 1905, to Ambroise Vollard, Paris; de
Rochecouste Collection, Paris, 1908; Georges Petit, Paris, 1909; acquired
through C.W. Kraushaar Galleries, New York, 1925.

(LONDON ONLY)

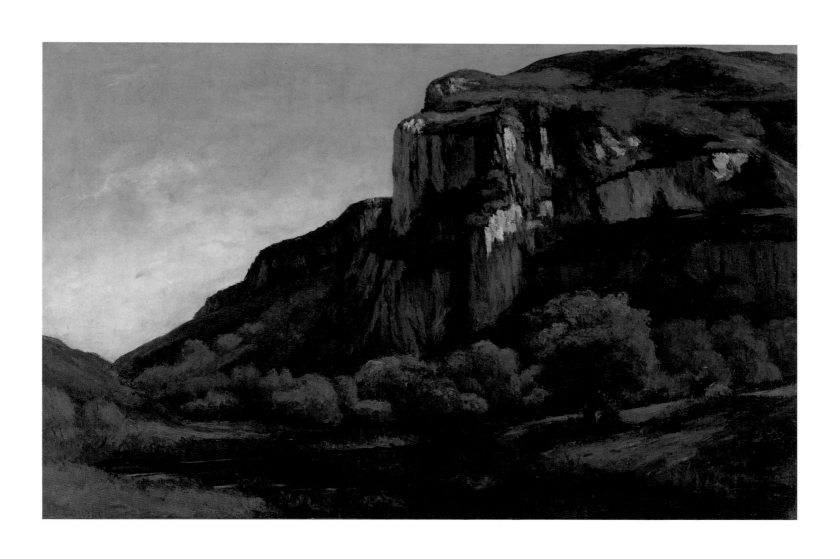

8

GUSTAVE COURBET

The Mediterranean 1857

oil on canvas

59.3 x 85 cm

(FRANKFURT AND MADRID ONLY)

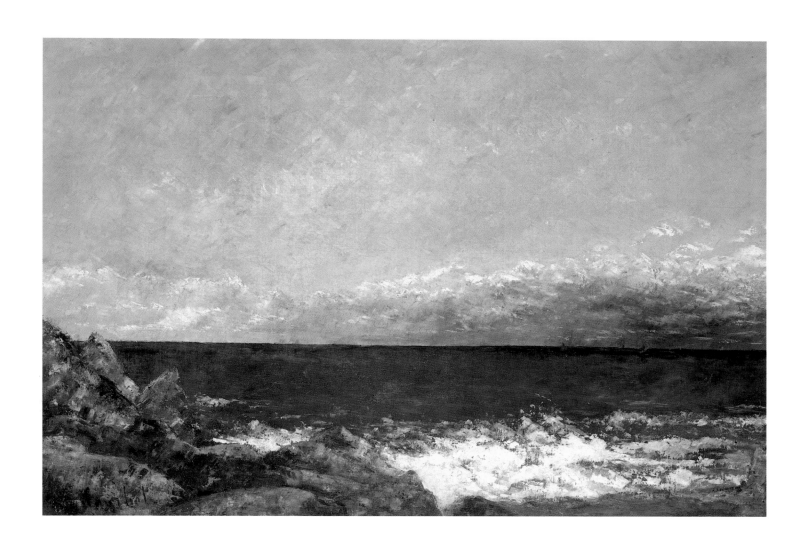

9

HONORÉ DAUMIER

The Uprising undated c. 1860

oil on canvas

87.6 x 113 cm

Henry Bing, Paris; Vigier (?), Paris, ca. 1904; H. Fiquet, Paris; acquired
through Leicester Galleries, London, 1925.

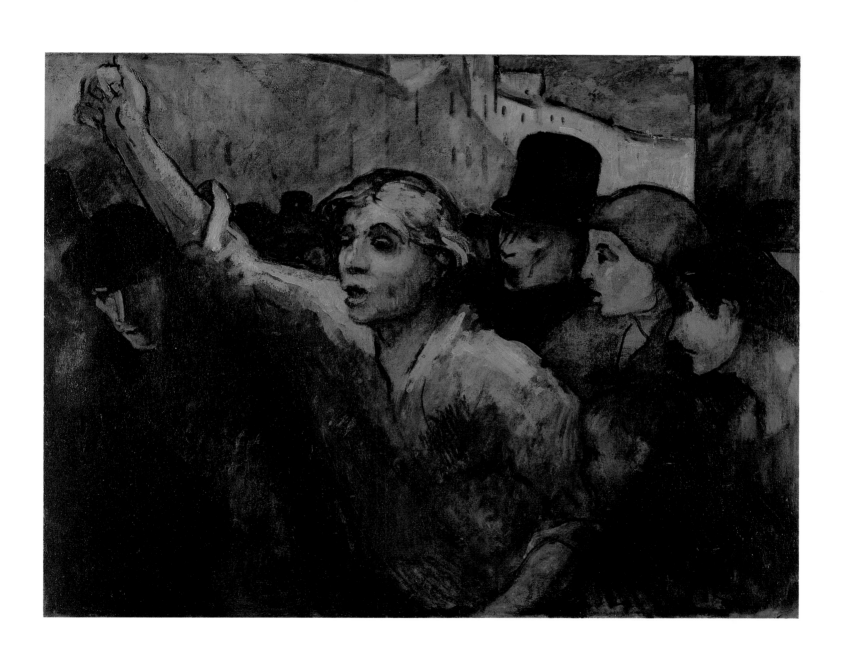

10

FERDINAND-VICTOR-EUGÈNE DELACROIX

Hercules and Alcestis 1862

oil on cardboard set in wood panel

32.3 x 48.8 cm

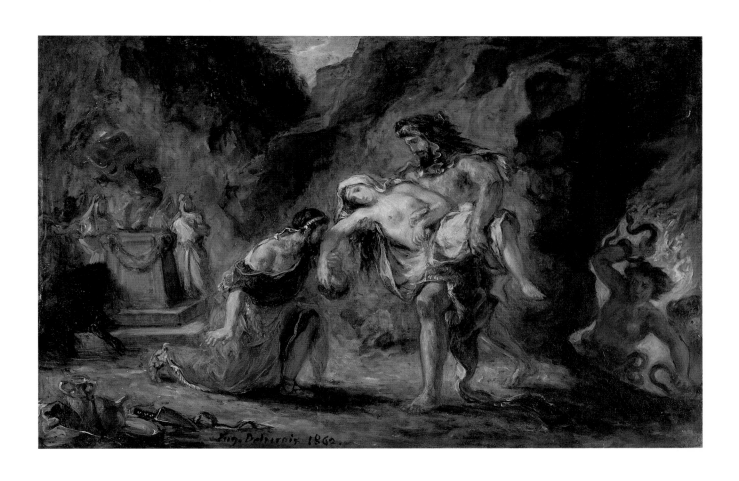

II

EDOUARD MANET

Ballet Espagnol 1862

oil on canvas

60.9 x 90.5 cm

The artist to Durand-Ruel, Paris, 1872; acquired from Durand-Ruel,

New York, 1928.

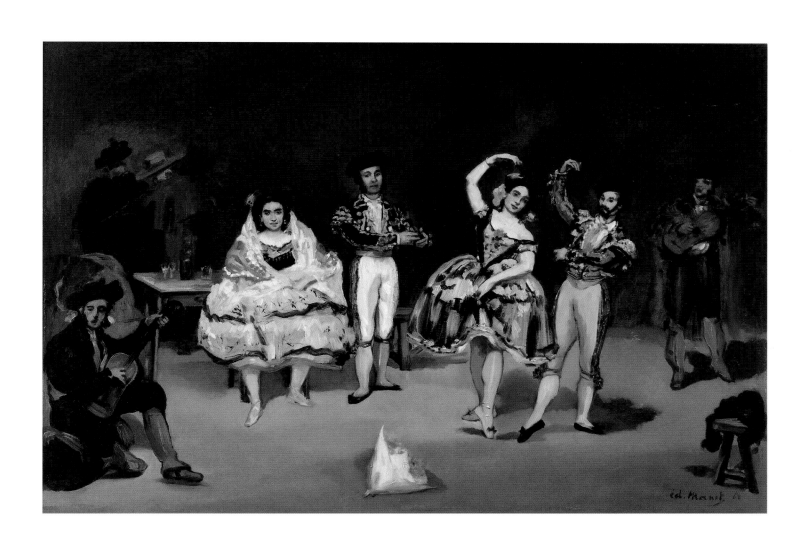

12
HONORÉ DAUMIER
The Strong Man c. 1865
oil on wood panel
26.6 x 34.9 cm

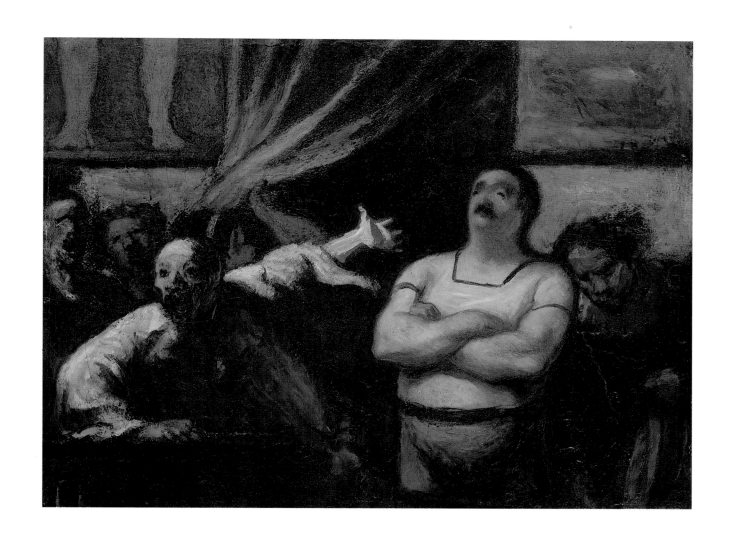

13
JEAN-BAPTISTE-CAMILLE COROT
Portrait of a Woman 1865-70
oil on canvas
41.2 x 33 cm

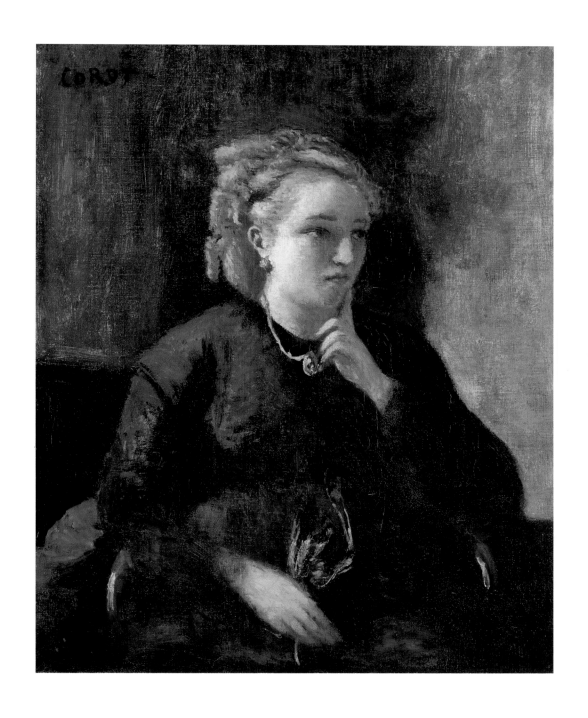

14

PIERRE PUVIS DE CHAVANNES
Marseilles, Gateway to the Orient 1868

oil on canvas

98.1 x 146.3 cm

Durand-Ruel, Paris; Baron Denys Cochin, Paris; Cochin sale, 1919, to
Bernheim-Jeune, Paris; Meyer Goodfriend Collection, New York;
Goodfriend sale, 1923; acquired through C.W. Kraushaar Galleries,
New York, 1923.

PIERRE PUVIS DE CHAVANNES
Massilia, Greek Colony 1868
oil on canvas
98.1 x 146.3 cm
(LONDON ONLY)

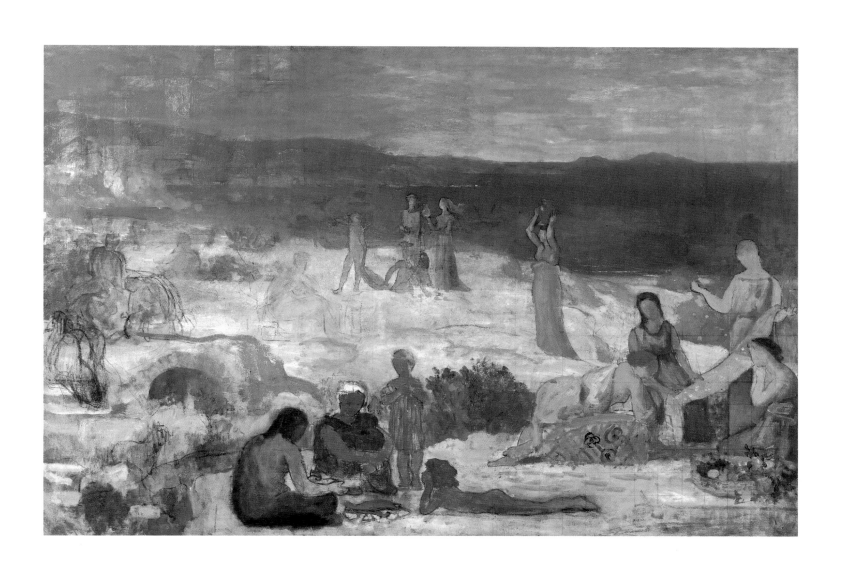

47

16

Hilaire-Germain-Edgar Degas

Melancholy c. 1874

oil on canvas

19 x 24.7 cm

17

ALFRED SISLEY

Snow at Louveciennes 1874

oil on canvas

55.9 x 45.7 cm

Kirkpatrick, London; Zygomalas, Paris; Alexander Rosenberg, Paris;
acquired from Paul Rosenberg, Paris, 1923.

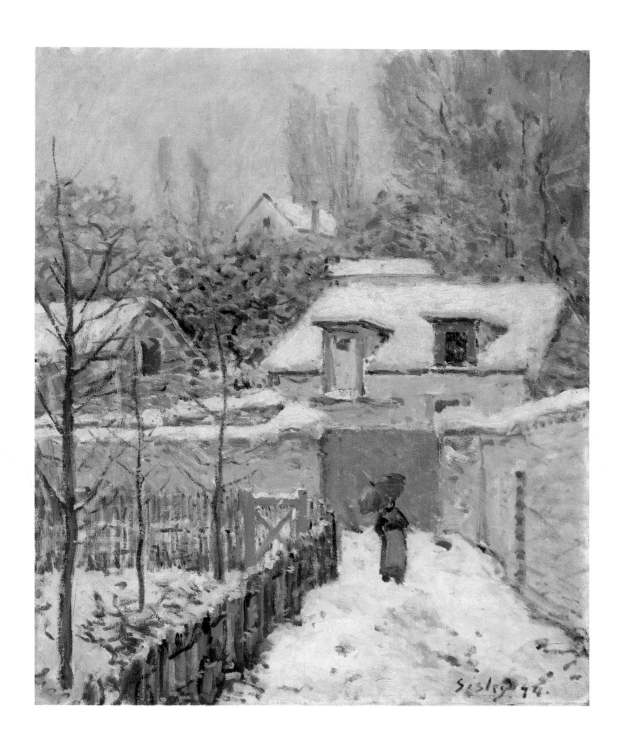

18

ADOLPHE MONTICELLI

Bouquet c. 1875

oil on wood panel

69.2 x 49.5 cm

Delpiano, Cannes; acquired from Paul Rosenberg & Co., New York, 1961.

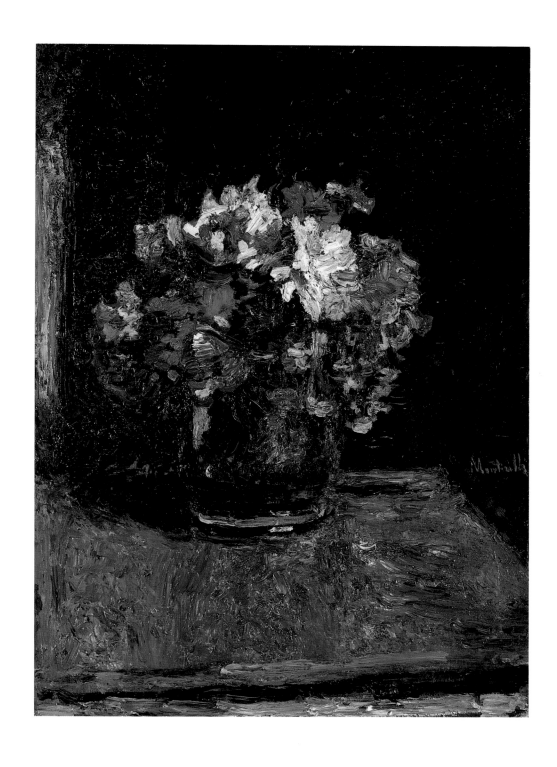

19

PAUL CÉZANNE

Self-Portrait 1878-80

oil on canvas

60.3 x 46.9 cm

Ambroise Vollard, Paris; Theodor Behrens, Hamburg;
Julius Meier-Graefe, Berlin; Paul Cassirer, Berlin; Baron and Baroness
Leo von Koenig, Schlachtensee; Paul Rosenberg, Paris; acquired from
Paul Rosenberg, New York, 1928.

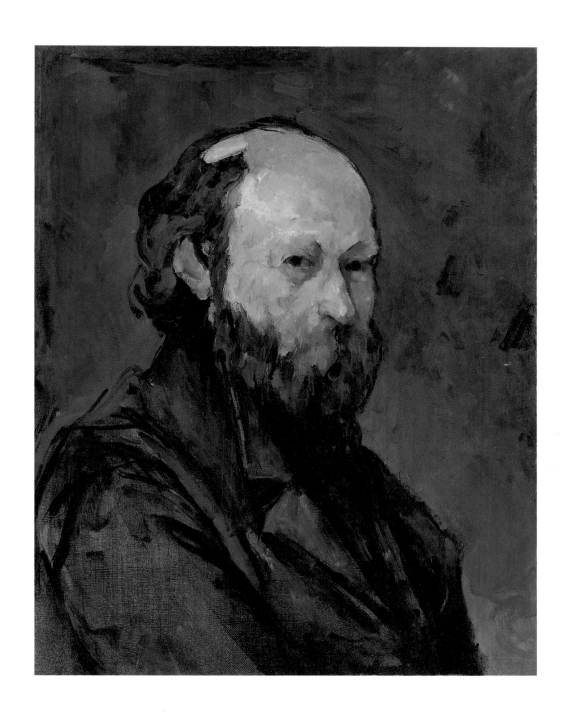

20

PIERRE-AUGUSTE RENOIR

The Luncheon of the Boating Party 1881

oil on canvas

129.5 x 172.7 cm

Durand-Ruel, Paris, 1881; sold to M. Balensi, December, 1881; sold back to
Durand-Ruel (Collection), April 1882; acquired from Durand-Ruel, 1923.

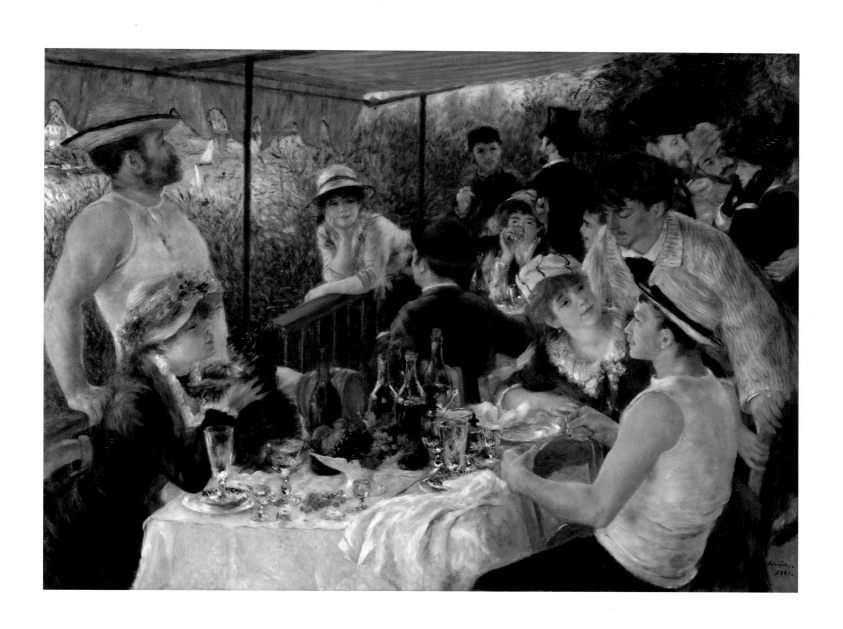

21

Georges Seurat

The Stone Breaker 1882

oil on wood panel

17.1 x 26 cm

22

PAUL CÉZANNE

Mont Sainte-Victoire 1886-87

oil on canvas

59.6 x 72.3 cm

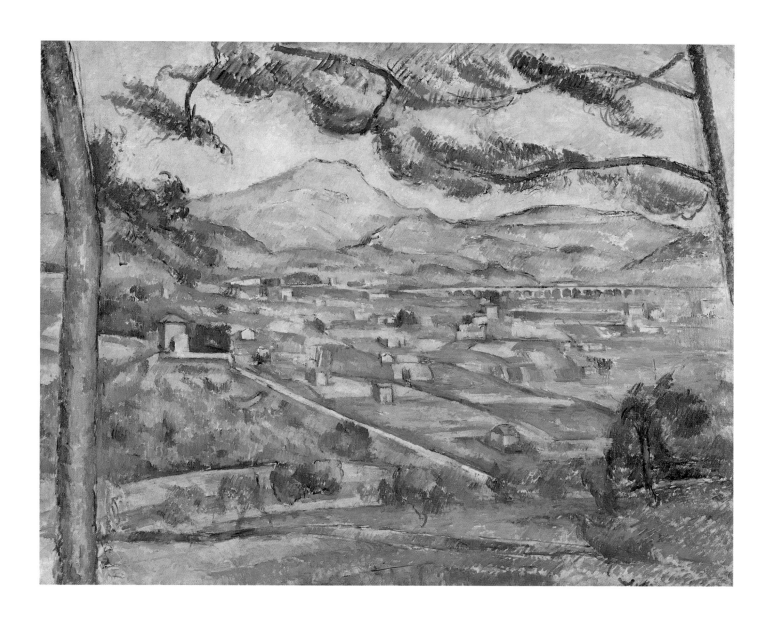

23

WILLIAM MERRITT CHASE
Hide and Seek 1888

oil on canvas
70.1 x 91.1 cm

24

Vincent van Gogh

Entrance to the Public Gardens in Arles 1888

oil on canvas

72.3 x 90.8 cm

Prince de Wagram, Paris; Madame Thea Sternheim, Uttwil,
Switzerland, from 1909; Frederick Muller & Co. sale, Amsterdam, 1919;
Karl Sternheim, Reichenberg; Arthur and Alice Sachs, New York;
acquired through Wildenstein & Co., New York, 1930.

25

VINCENT VAN GOGH

The Road Menders 1889

oil on canvas

73.6 x 92.7 cm

26
WINSLOW HOMER
Rowing Home 1890
watercolour on paper
39.9 x 50.4 cm

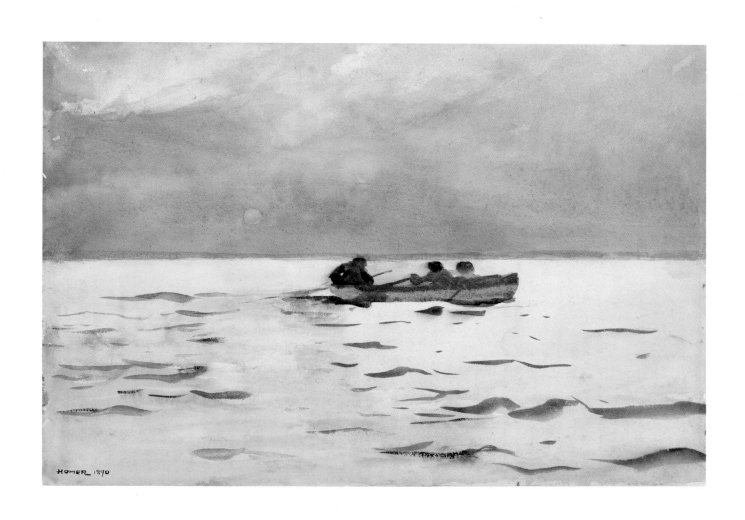

27

ALBERT PINKHAM RYDER

Macbeth and the Witches 1890-1908

oil on canvas

71.7 x 90.8 cm

(LONDON ONLY)

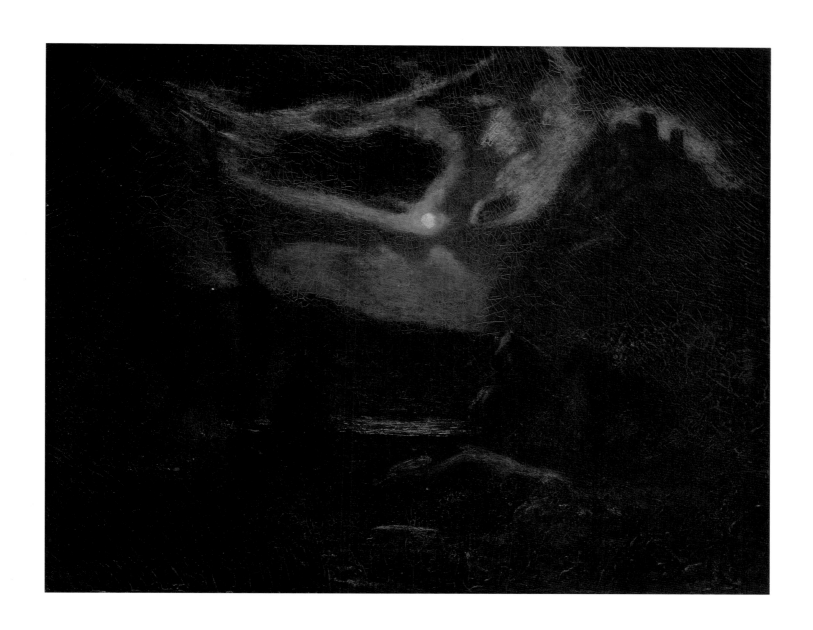

28

PAUL CÉZANNE

Ginger Pot with Pomegranate and Pears 1890-93

oil on canvas

46.3 x 55.5 cm

Claude Monet, Giverny; Michel Monet; Bernheim-Jeune, Paris;
Joseph Stransky, New York, until 1937; acquired through Wildenstein
& Co., New York, 1939. Gift of Gifford Phillips.

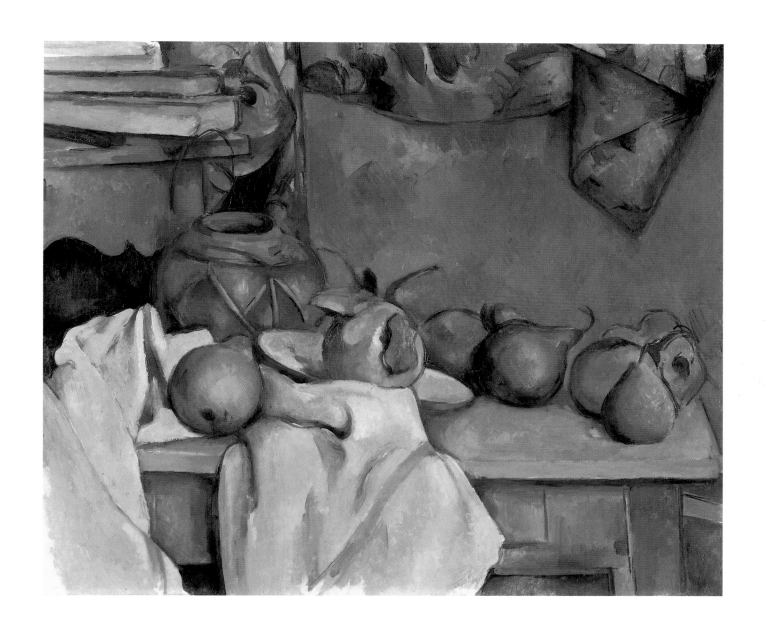

29

EDOUARD VUILLARD

Woman Sweeping c. 1892

Oil on cardboard

44.1 x 47.3 cm

Bernheim-Jeune, Paris, 1916; Josse Bernheim, 1918; acquired from
Jacques Seligmann & Co., Inc., New York, 1938.

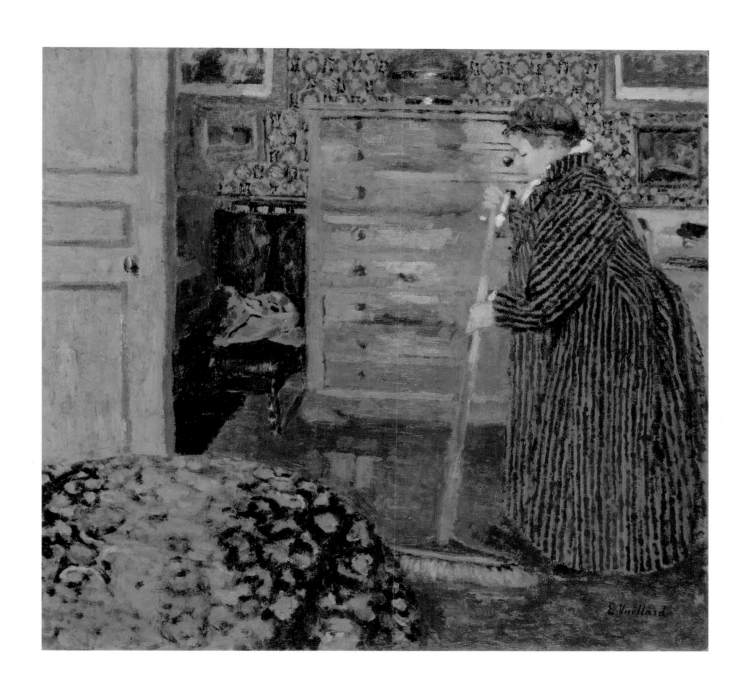

30
BERTHE MORISOT
Two Girls undated c. 1894
oil on canvas
66 x 54.6 cm

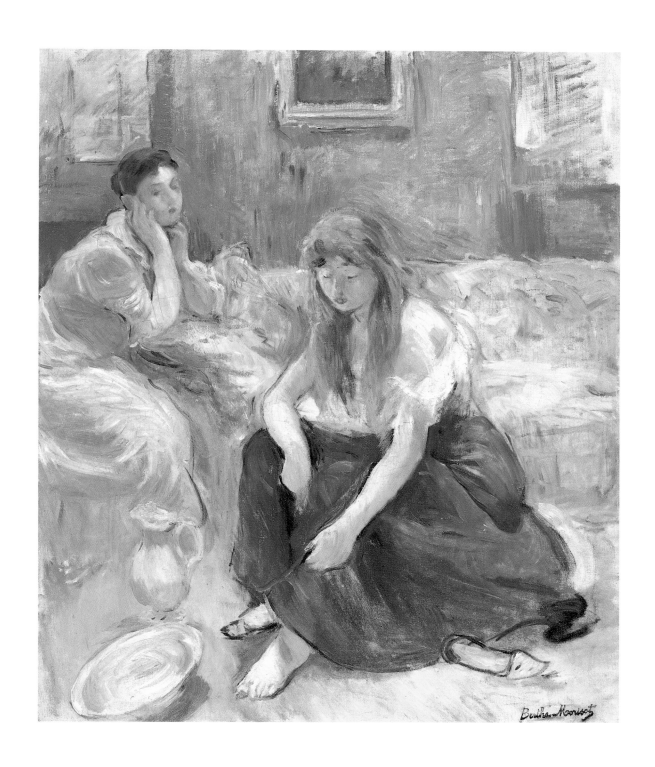

31

CLAUDE MONET

On the Cliffs, Dieppe 1897

oil on canvas

65.1 x 100 cm

The artist to Durand-Ruel, Paris, 1898; Durand-Ruel Collection until
1955; through Galerie Charpentier to M. Fellion. Paris, 1955, and
directly thereafter to World House Galleries, New York; acquired
from World House Galleries, 1959.

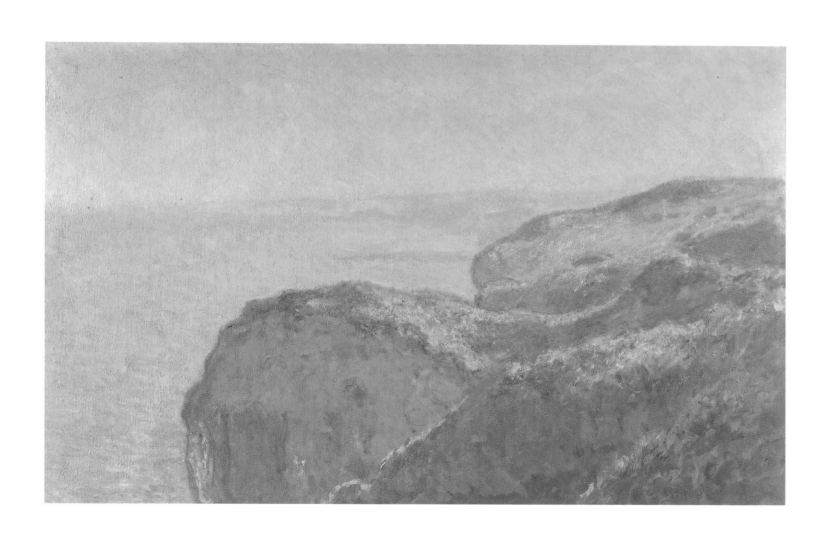

32

KER-XAVIER ROUSSEL

Faun and Nymph Under a Tree undated c. 1900

oil on canvas

43.1 x 58.4 cm

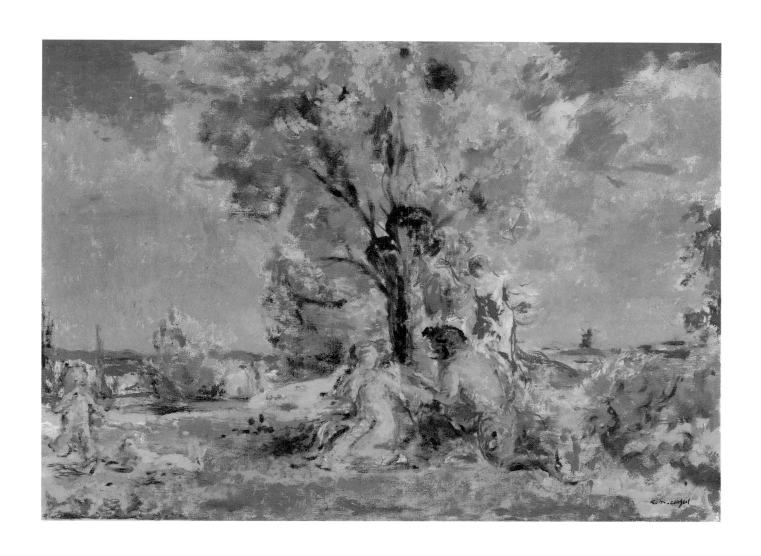

33
ODILON REDON
Mystery undated c. 1900
oil on canvas
73 x 53.9 cm
Mme. Redon; acquired through C.W. Kraushaar Galleries, New York, 1925.

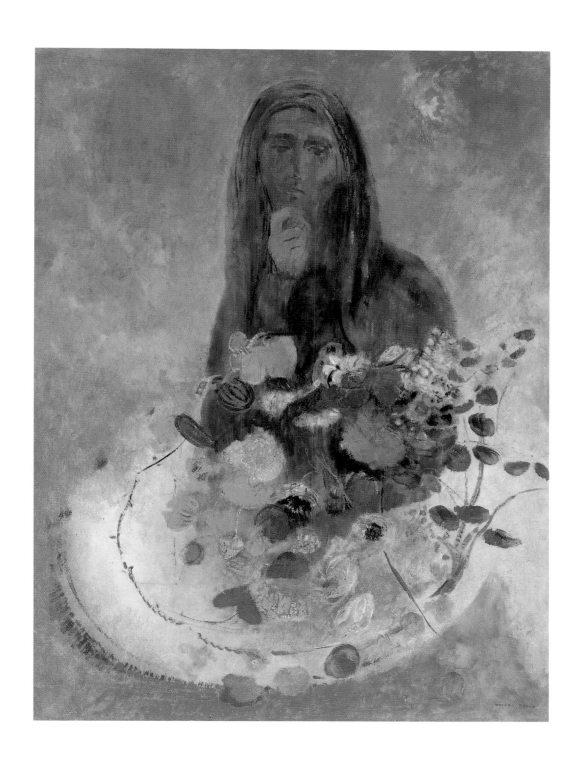

34

PABLO PICASSO

The Blue Room 1901

oil on canvas

50.4 x 61.5 cm

Wilhelm Uhde, Paris; Etienne Bignou, Paris; Alfred Gold, Berlin; Reid
& Lefevre, Ltd., London, 1926; Wildenstein & Co., Inc., New York, 1927;
acquired from Wildenstein, 1927.

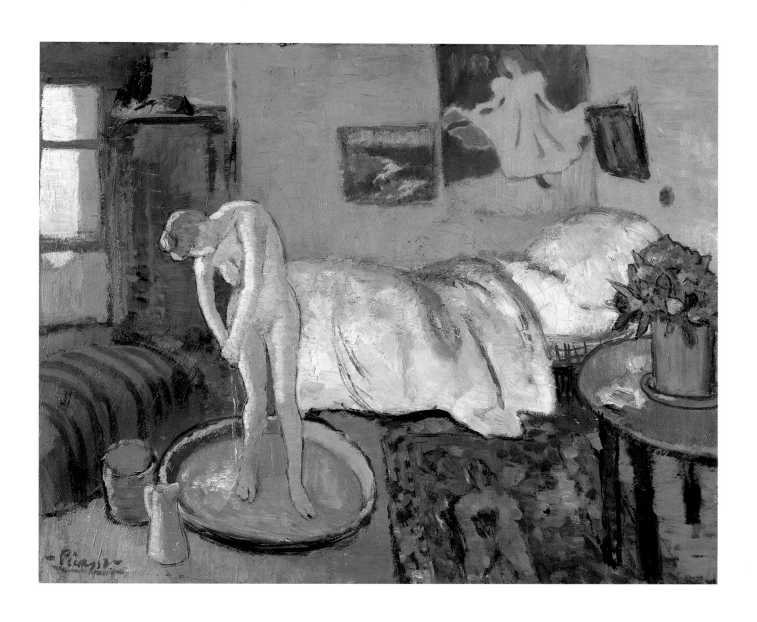

35
PABLO PICASSO
Still Life with Portrait 1905
oil on canvas
81.9 x 100.4 cm
Estate of Marjorie Phillips

36

HENRI ROUSSEAU

The Pink Candle 1905-08

oil on canvas

16.2 x 22.2 cm

Galerie Bignou, Paris; Workman Collection, London; Reid & Lefevre,
London; acquired from M. Knoedler & Co., Inc., New York, 1930.

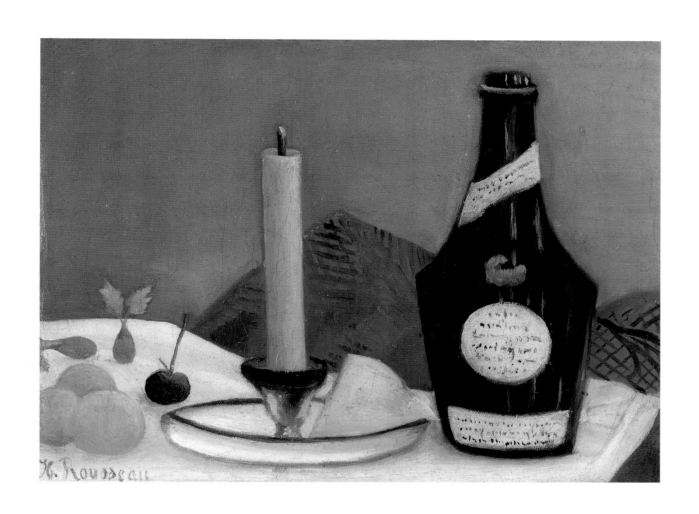

37
JOHN SLOAN
The Wake of the Ferry II 1907
oil on canvas
66 x 81.3 cm
Acquired from C.W. Kraushaar Galleries, New York, 1922.

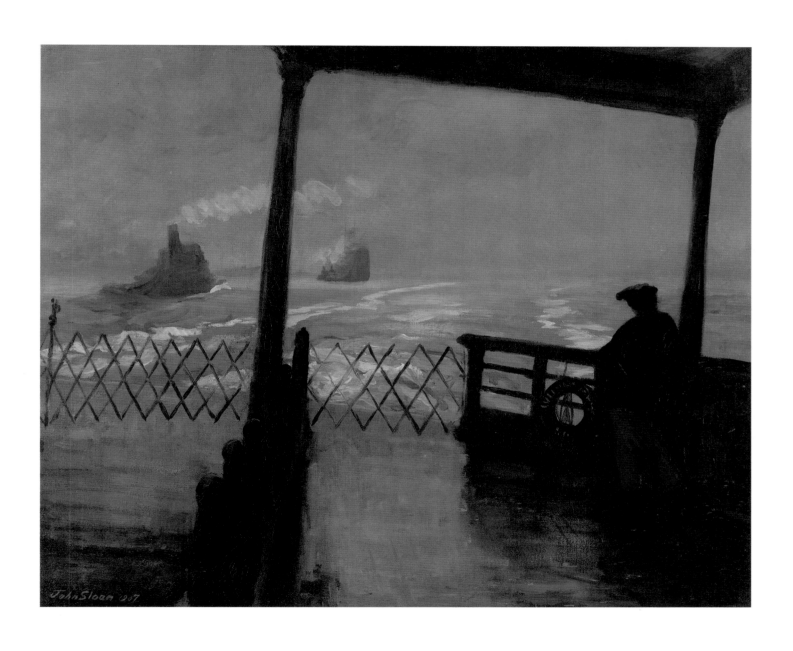

38

MAURICE UTRILLO

Place du Tertre 1911

oil on cardboard mounted on masonite

54.6 x 73.6 cm

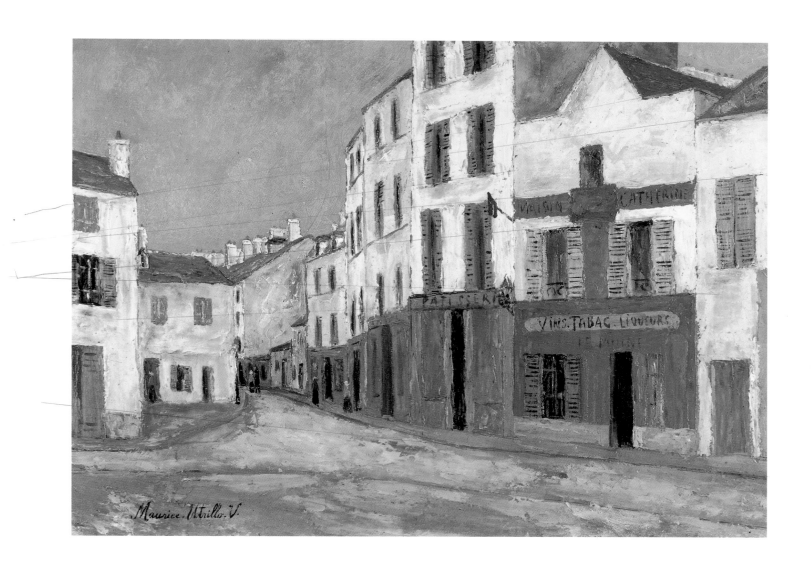

39
WASSILY KANDINSKY
Autumn II 1912
oil and oil washed on canvas
60.9 x 82.5 cm

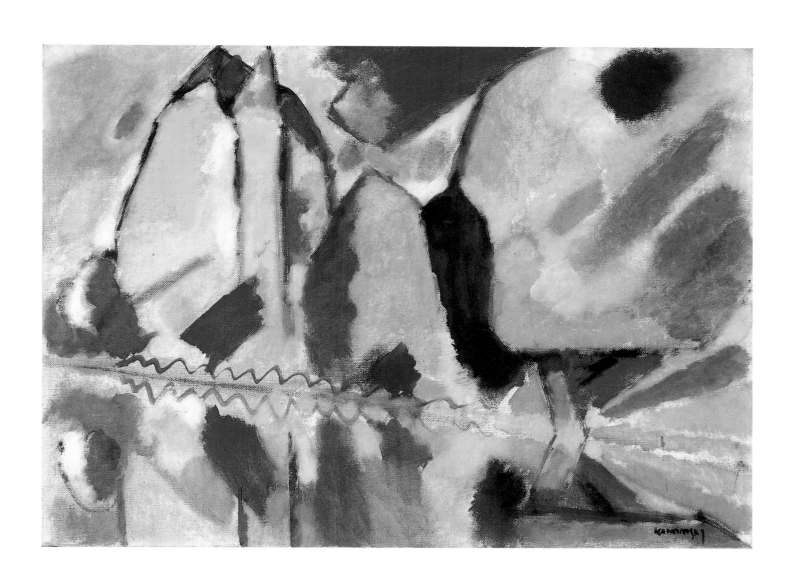

40

ROGER DE LA FRESNAYE

Emblems c. 1913

oil on canvas

88.9 x 200 cm

Georges de Miré, Versailles; Jacques Seligmann & Co., New York;

acquired 1939.

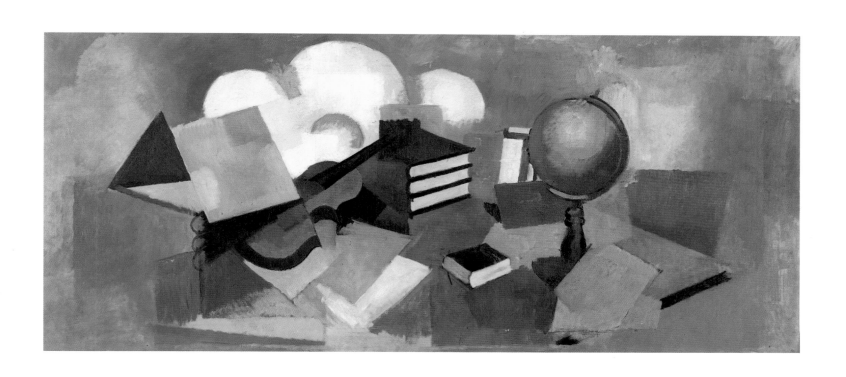

41
WASSILY KANDINSKY
Sketch for Painting with White Border 1913
oil on burlap canvas
99.6 x 78.1 cm

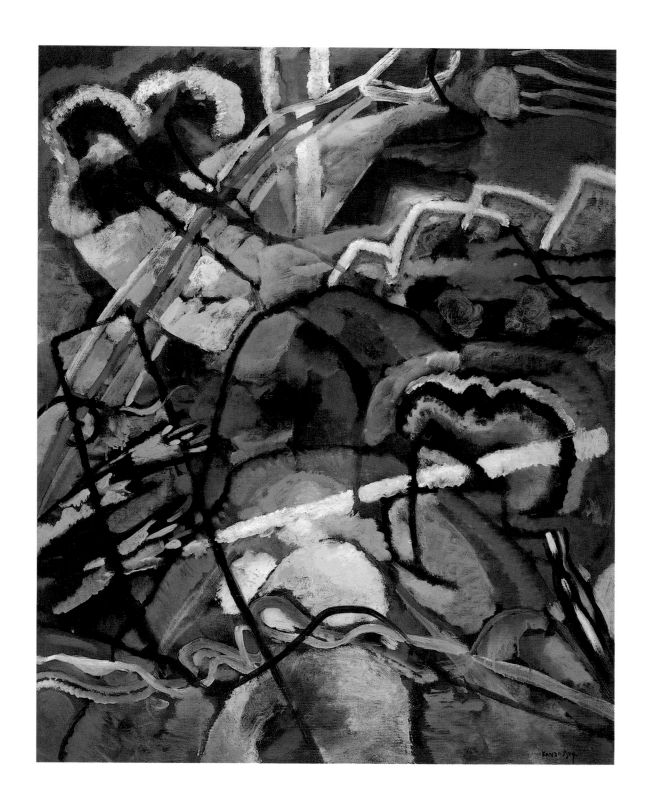

42

FRANZ MARC

Deer in Forest I 1913

oil on canvas

100.9 x 104.7 cm

The artist's widow to Katherine S. Dreier, 1927; acquired 1953,

Katherine S. Dreier Bequest.

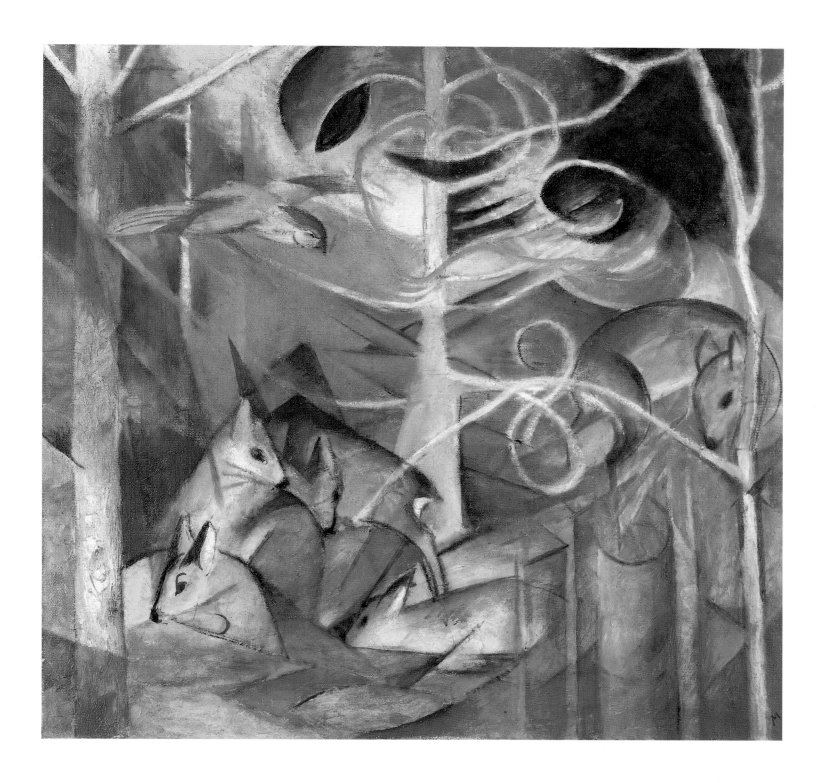

43
JUAN GRIS
Still Life with Newspaper 1916
oil on canvas
73.6 x 60.3 cm
Léonce Rosenberg, Paris; Katherine S. Dreier, Connecticut, 1922;
acquired from Dreier, 1950, as *Black, Grey and White*.

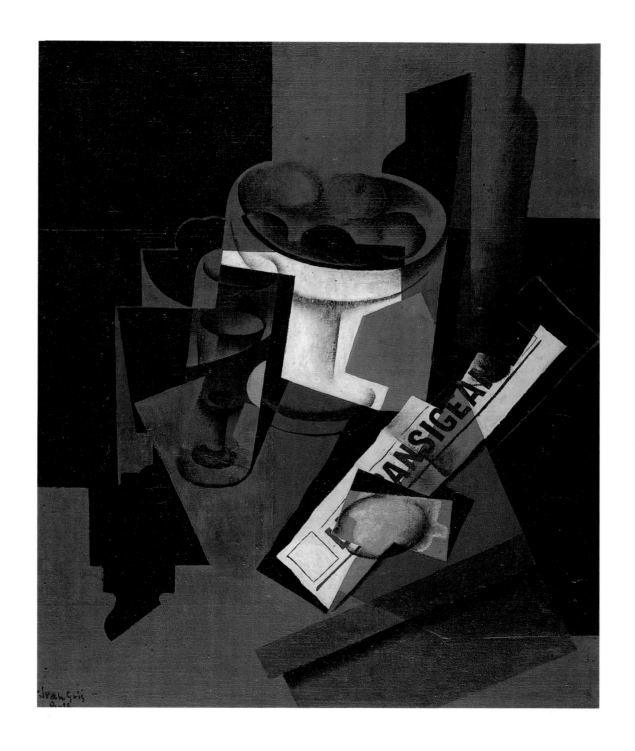

44

AMEDEO MODIGLIANI

Elena Pavlowski 1917

oil on canvas

64.7 x 48.8 cm

Pavlowski Collection, Paris; Pierre Matisse, 1947; acquired from Pierre
Matisse Gallery, New York, 1949.

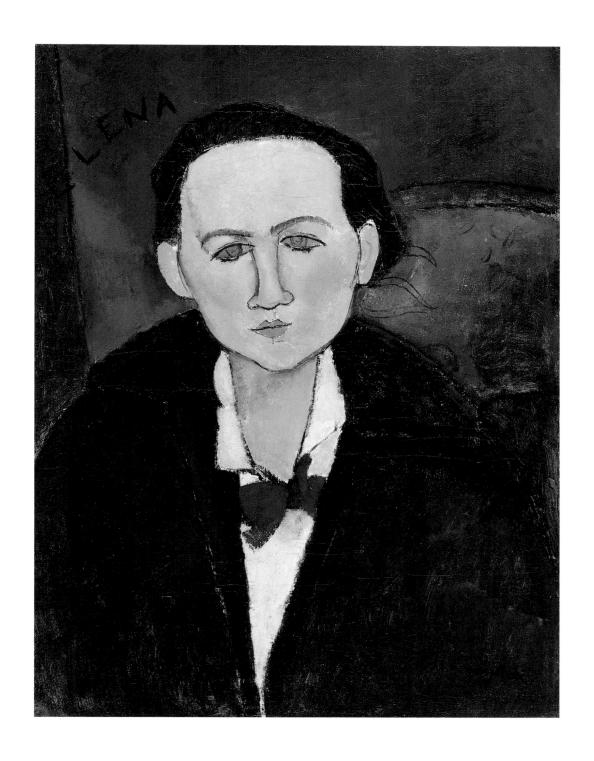

45

GEORGE LUKS

*Otis Skinner as Colonel Phillipe Bridau in
'The Honor of His Family'* 1919

oil on canvas

132 x 111.7 cm

Commissioned by Duncan Phillips, 1919; acquired through
C.W. Kraushaar

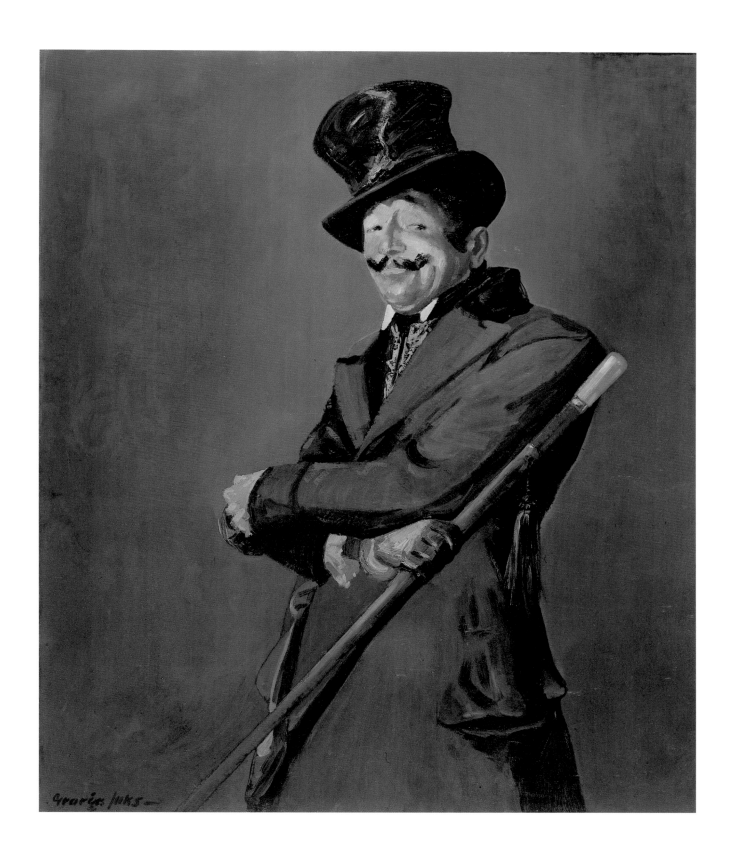

47
GEORGES BELLOWS
Emma in Black 1920
oil on canvas
101.6 x 83.8 cm

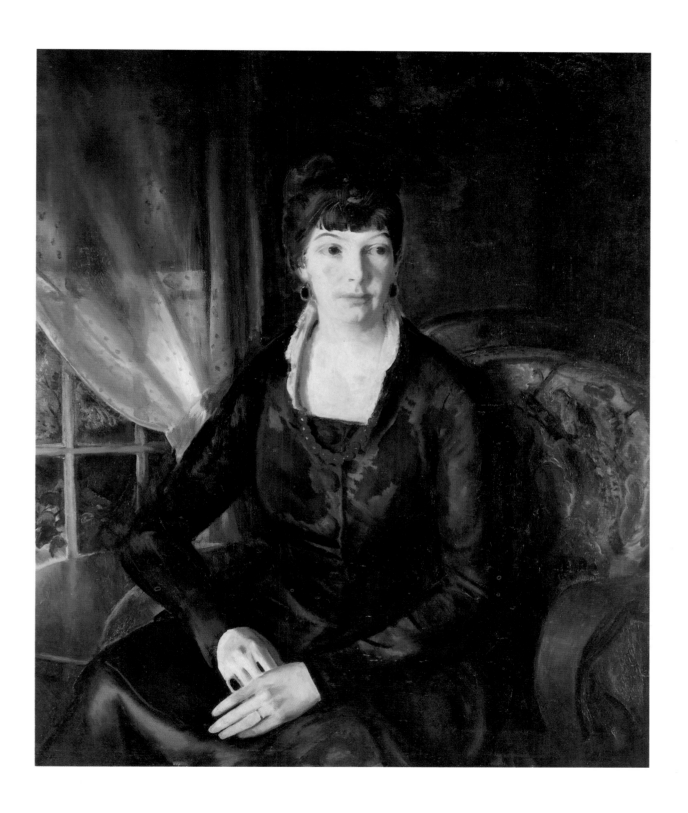

48

KURT SCHWITTERS

Radiating World 1920

oil and paper collage on cardboard

95.2 x 67.9 cm

Katherine S. Dreier Bequest.

(FRANKFURT AND MADRID ONLY)

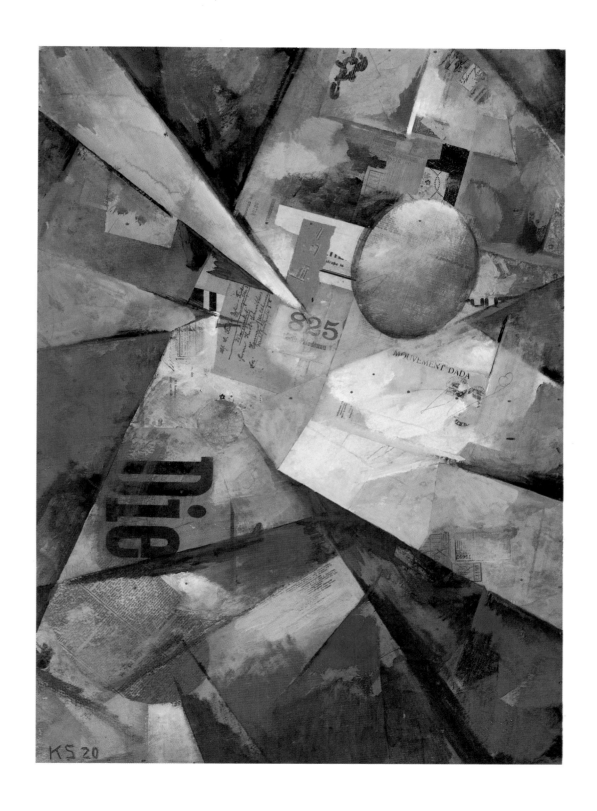

49

PIERRE BONNARD

The Open Window 1921

oil on canvas

118 x 96 cm

The artist to Bernheim-Jeune, Paris, 1922; G. Besnard, Paris; acquired
through Jacques Seligmann & Co., Inc., New York, 1930.

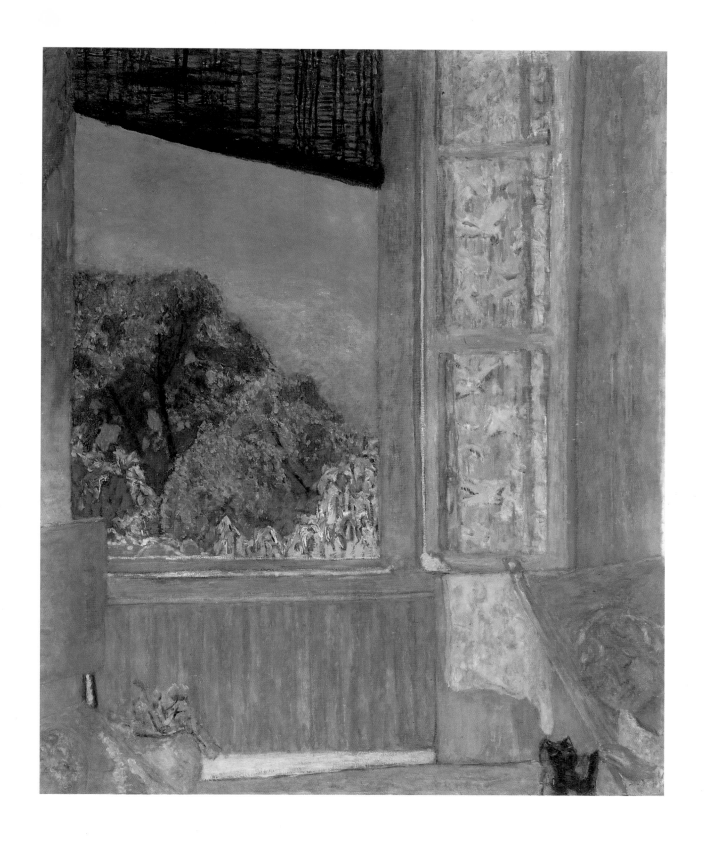

50

PIERRE BONNARD

Woman with Dog 1922

oil on canvas

62.9 x 39.3 cm

The artist to Bernheim-Jeune, Paris, 1923; acquired from

Bernheim-Jeune, 1925.

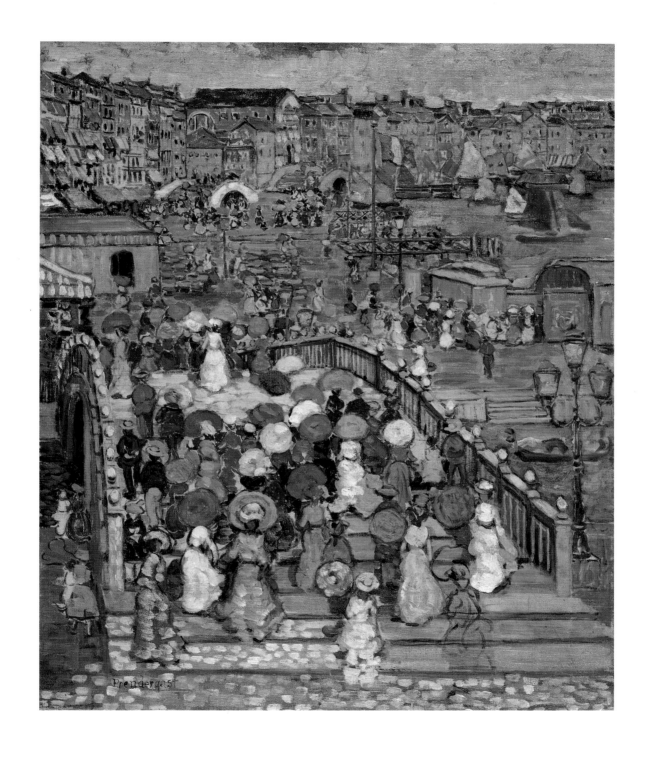

53
PIET MONDRIAN
Square Composition 1922-25
oil on canvas
48.8 x 48.8 cm

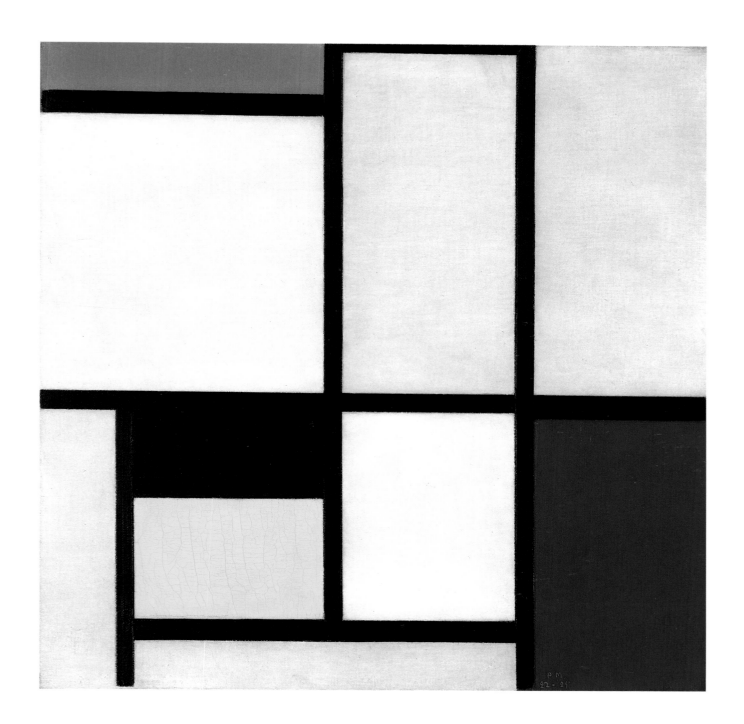

54
JOHN D. GRAHAM
Woman and Two Horses 1925
oil on canvas
53.3 x 63.8 cm
(LONDON ONLY)

55
PIERRE BONNARD
The Palm 1926
oil on canvas
114.3 x 147 cm
Félix Fénéon, Paris; acquired from de Hauke & Co., New York, 1928.

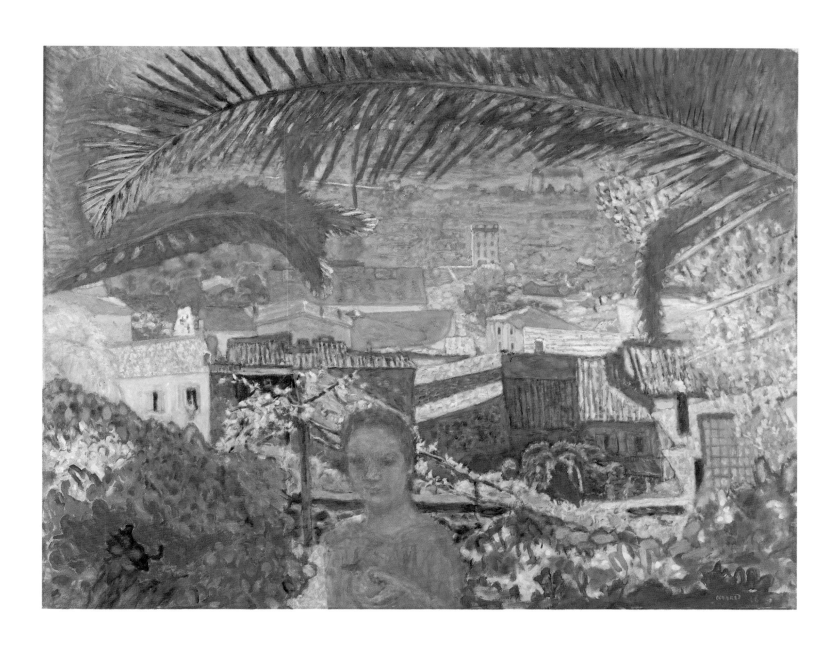

56
GEORGES BRAQUE
Plums, Pears, Nuts and Knife 1926
oil on canvas
22.8 x 73 cm

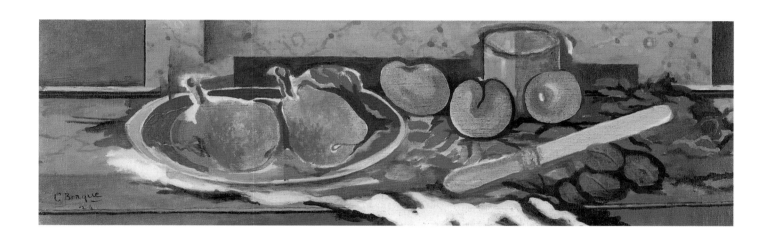

57

Georges Braque

Still Life with Grapes and Clarinet 1927

oil on canvas

53.9 x 73 cm

Acquired from Reinhardt Galleries, New York, 1930.

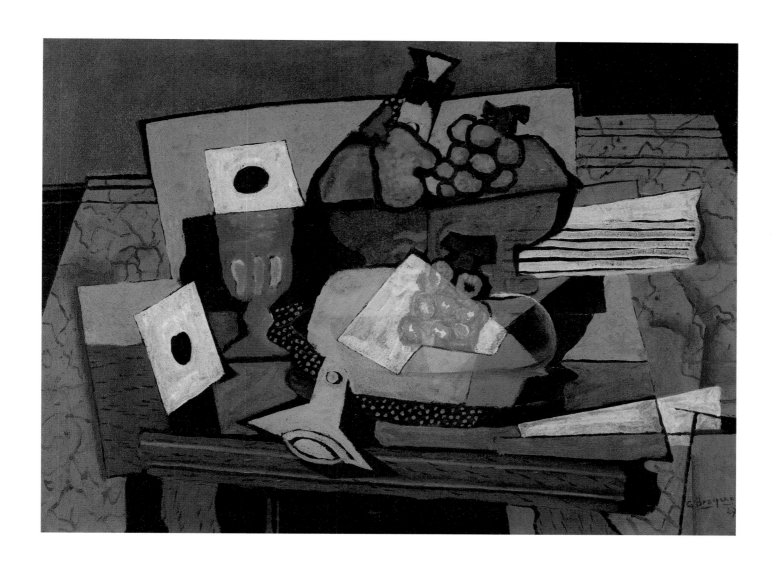

58
STUART DAVIS
Egg Beater No. 4 1927
oil on canvas
68.5 x 97.1 cm

133

59
ANDRÉ DERAIN
Southern France 1927
oil on canvas
76.2 x 93.3 cm

61

GEORGES BRAQUE

The Round Table 1929

oil on canvas

145.4 x 113.6 cm

62
OSKAR KOKOSCHKA
Lac d'Annecy II 1930
oil on canvas
75.5 x 100.6 cm

63
WALT KUHN
Show Girl with Plumes 1931
oil on canvas
101.6 x 76.5 cm

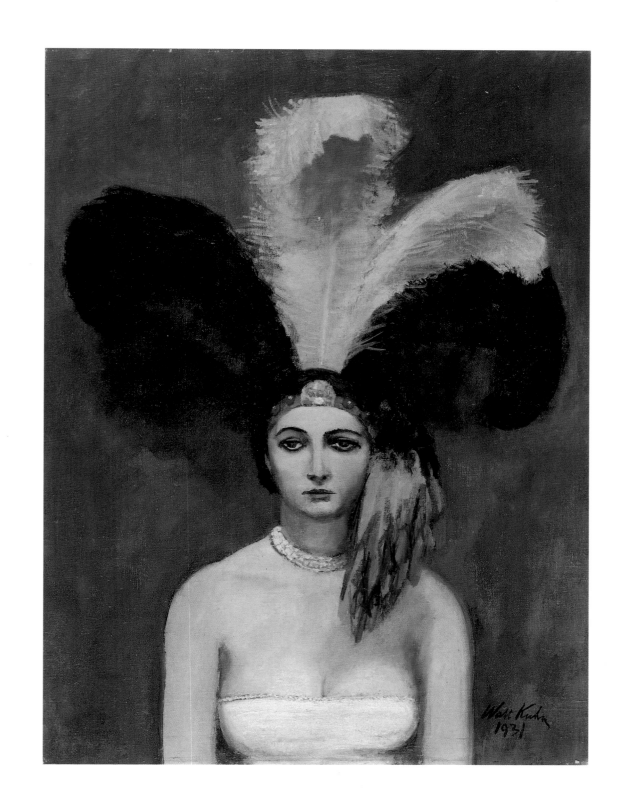

143

64
PAUL KLEE
Arab Song 1932
gouache on unprimed burlap
91.1 x 64.7 cm
Acquired from Karl Nierendorf, New York, 1941.

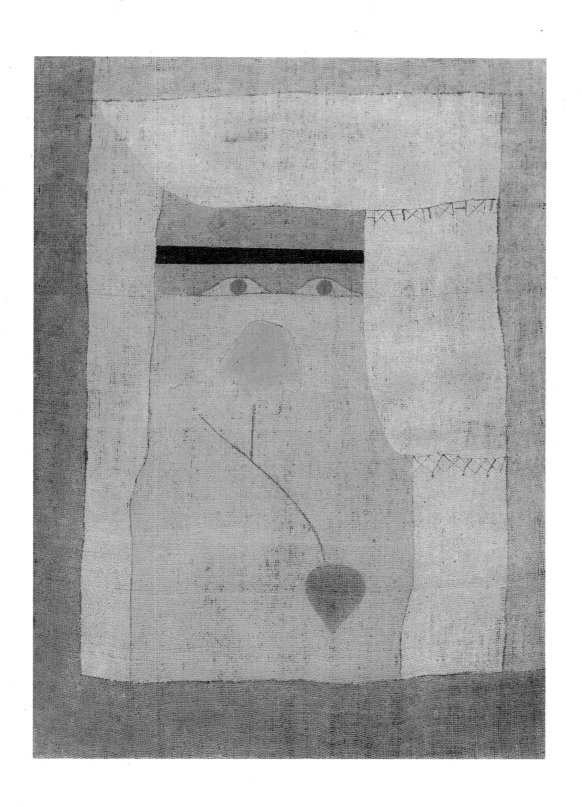

65

PIERRE BONNARD

Nude in an Interior c. 1935

oil on canvas

73 x 50.2 cm

Dr. and Mrs. Frederick B. Deknatel, Cambridge, Massachussetts; to M.
Knoedler & Co., Inc., New York, 1951; to Sidney Janis, New York,
1952; acquired from Sidney Janis, 1952.

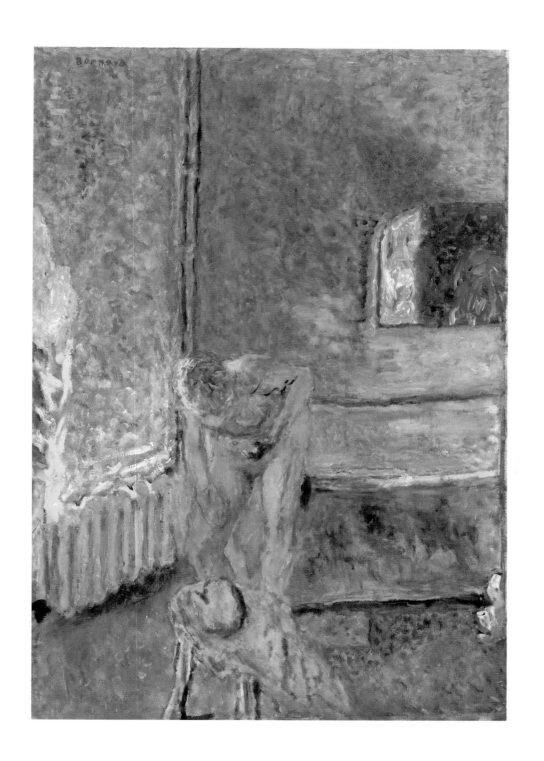

66
RAOUL DUFY
The Artist's Studio 1935
oil on canvas
119 x 147.9 cm

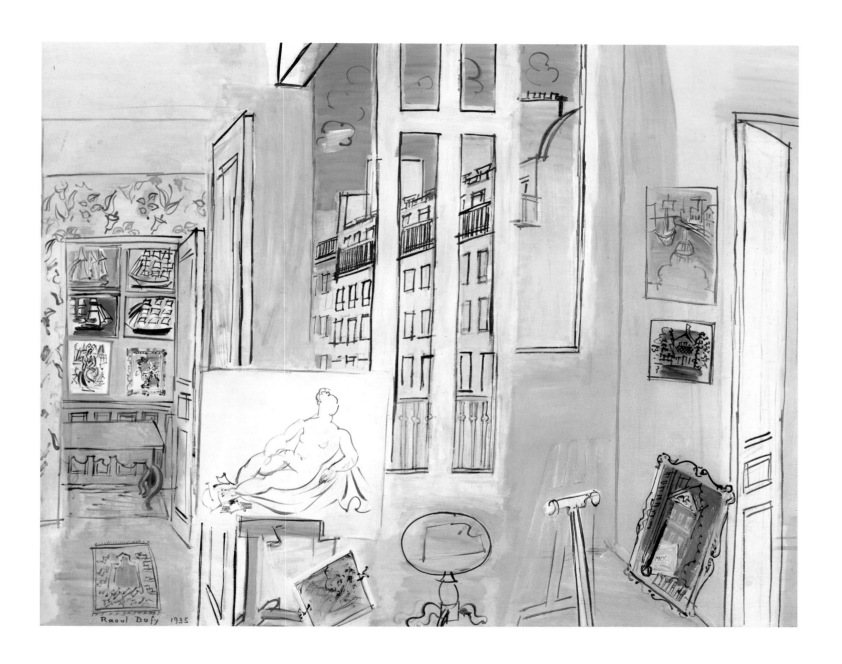

67

OSKAR KOKOSCHKA

Prague: View from the Moldau Pier I possibly 1936

oil on canvas

96.5 X 132 cm

(FRANKFURT AND MADRID ONLY)

68
Paul Klee
Picture Album 1937
gouache on unprimed canvas
59.3 x 56.5 cm

153

69
ARTHUR G. DOVE
Flour Mill II 1938
wax emulsion on canvas
66 x 40.6 cm

70
PAUL KLEE
Young Moe 1938
gouache on newspaper mounted on burlap
53 x 70.8 cm
(FRANKFURT AND MADRID ONLY)

71
GEORGES ROUAULT
Verlaine c. 1939
oil on canvas
100.9 x 73.9 cm

72

Chaim Soutine

Return from School After the Storm 1939

oil on canvas

43.1 x 49.5 cm

73

PIET MONDRIAN

Painting No. 9

(Composition in Black, White, Yellow and Red) 1939-42

oil on canvas

79.3 x 73.9 cm

The artist to Katherine S. Dreier, Connecticut, 1942; acquired 1953,

Katherine S. Dreier Bequest.

(FRANKFURT AND MADRID ONLY)

74
GEORGIA O'KEEFFE
From the White Place 1940
oil on canvas
76.2 x 60.9 cm

75
MILTON AVERY
Girl Writing 1941
oil on canvas
121.9 x 81.6 cm
Acquired through Valentine Gallery, Inc., New York.

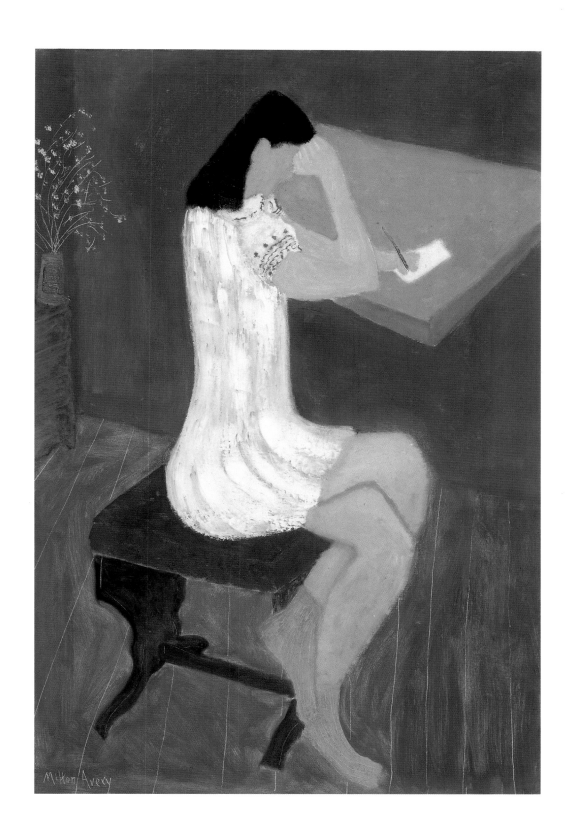

76

Marsden Hartley

Off the Banks at Night 1942

oil on masonite

76.2 x 101.6 cm

77
EDWARD HOPPER
Approaching a City 1946
oil on canvas
68.9 x 91.4 cm
Acquired through Frank K.M. Rehn, Inc., New York, 1947.

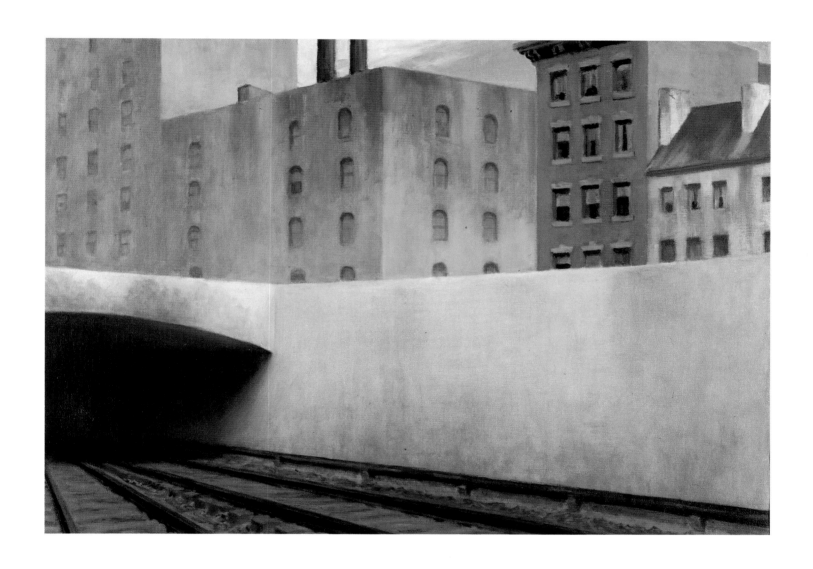

78
KARL KNATHS
The Moors 1947
oil on canvas
68.5 x 91.4 cm

79
HENRI MATISSE
Interior with Egyptian Curtain 1948
oil on canvas
116.2 x 89.2 cm

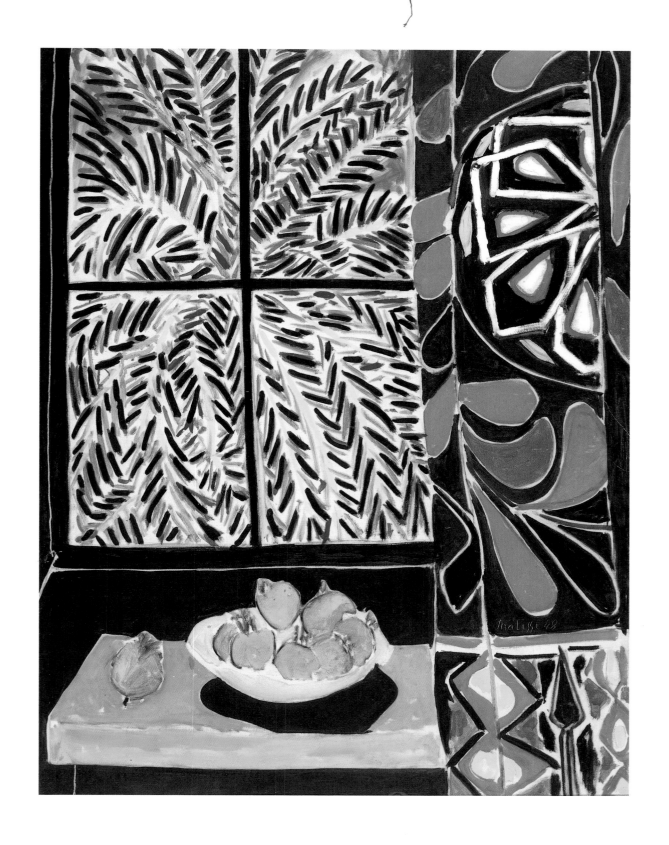

80

JOAN MIRÓ

The Red Sun 1948

oil on canvas

91.1 x 71.1 cm

Acquired from Pierre Matisse Gallery, New York, 1951.

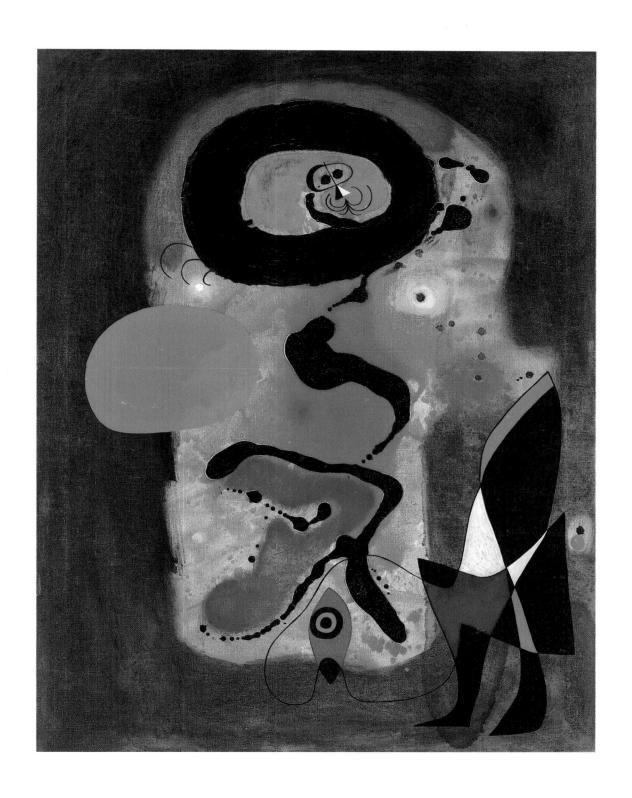

81

FRANCIS BACON

Study of a Figure in a Landscape 1952

oil on canvas

198.1 x 137.7 cm

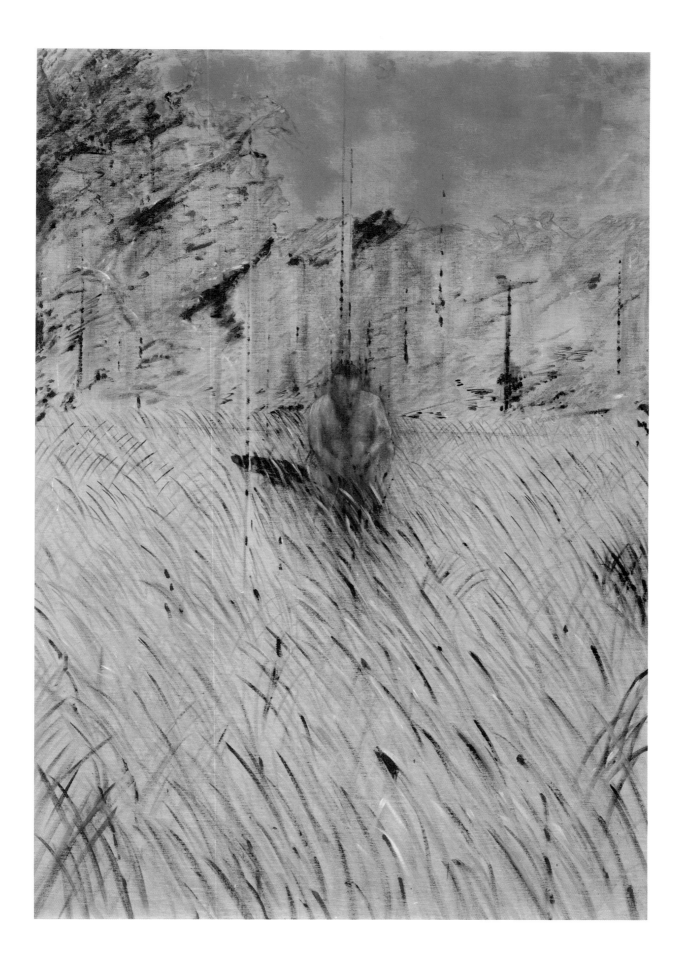

85
MARK ROTHKO
Green and Maroon 1953
oil on canvas
231.8 x 139.1 cm
The artist through Sidney Janis Gallery, New York, 1957.

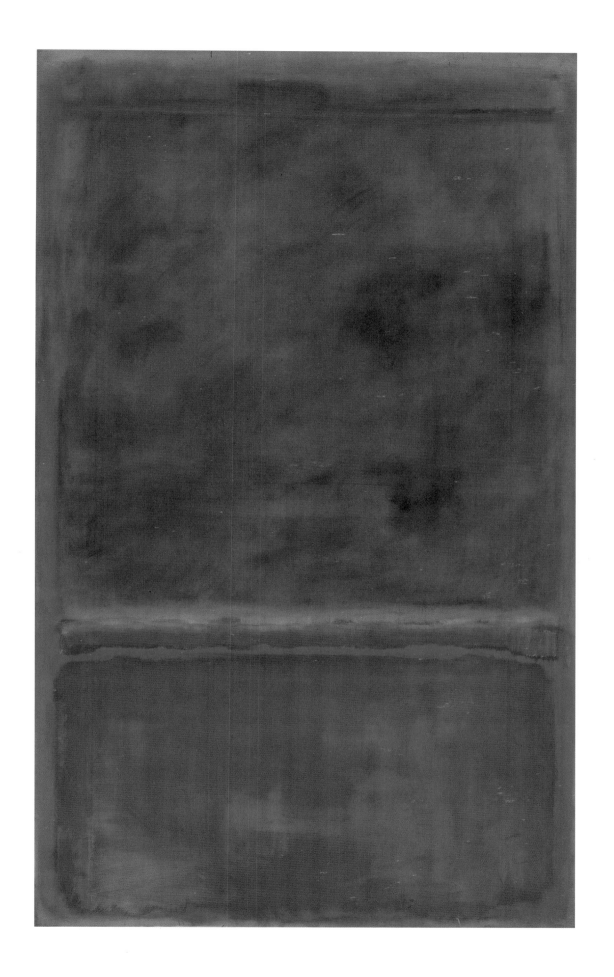

86

MARK ROTHKO

Ochre and Red on Red 1954

oil on canvas

235.3 x 161.9 cm

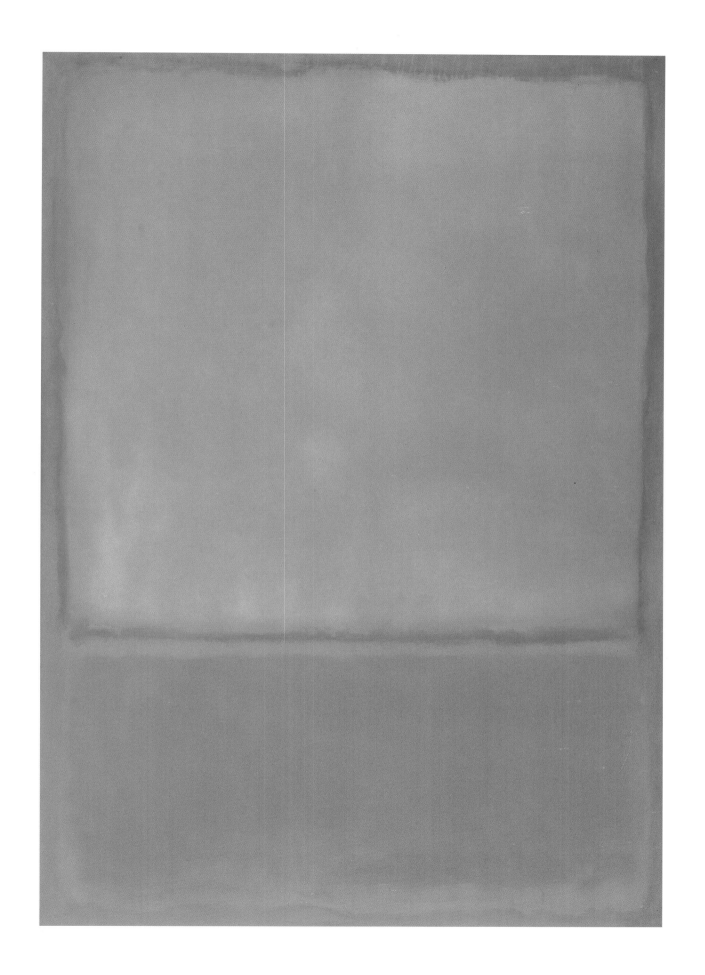

87

Philip Guston

Native's Return 1957

oil on canvas

164.7 x 192.7 cm

Acquired through Sidney Janis, New York, 1958.

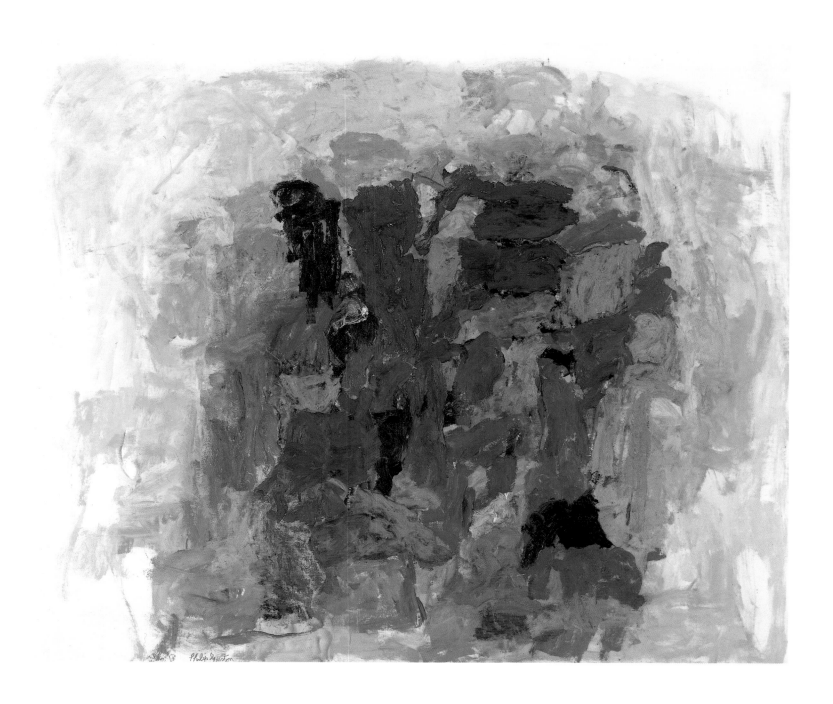

88

SAM FRANCIS

Blue 1958

oil on canvas

121.9 x 88.2 cm

The artist through Martha Jackson Gallery, New York, 1958.

(FRANKFURT AND MADRID ONLY)

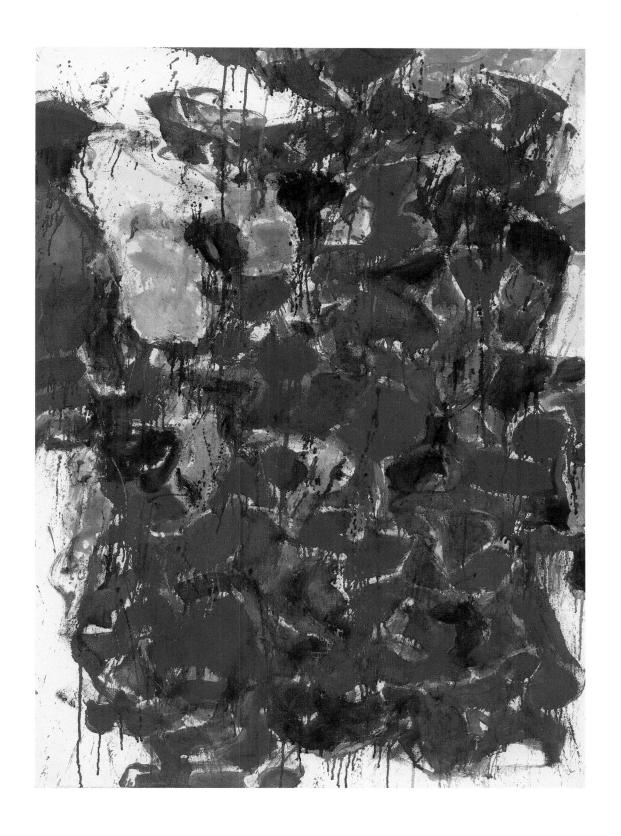

89
RICHARD DIEBENKORN
Girl with Plant 1960
oil on canvas
203.2 x 177.8 cm

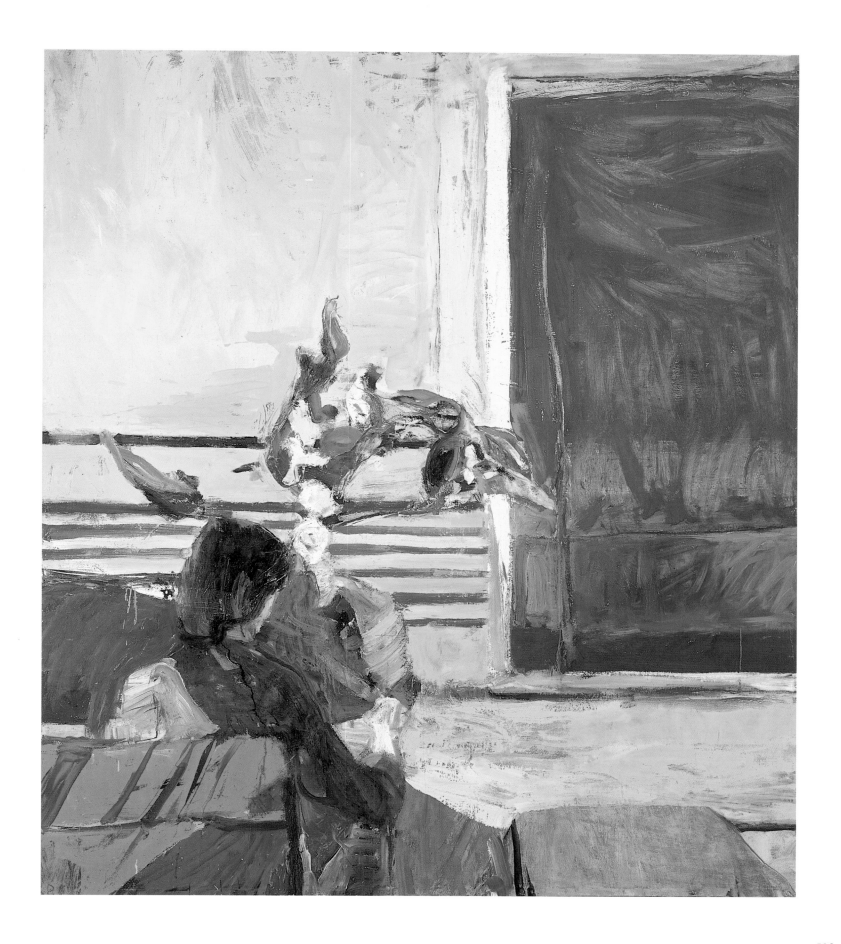

90
FRANK STELLA
Pilicia II 1973
Mixed media assemblage
279.4 x 249 cm

91
JOHN WALKER
Untitled 1976
acrylic, chalk, gel and canvas
228.6 x 173.3 cm
(LONDON ONLY)

92
SEAN SCULLY
Red and Red 1986
oil on canvas
228.6 x 292 cm (three panels)
Gift of the Friends of Marjorie Phillips in her memory, 1986.
(LONDON ONLY)

Biographies

ARCHIPENKO, Alexander

b. Kiev, Ukraine 1887, d. New York 1964

pl. 46

Archipenko was important among the generation of 'cubist' sculptors, and many consider his most creative period to have been before the First World War. After training in Russia, Archipenko arrived in Paris at the age of 21, one of a generation of immigrant artists. His studies in the Louvre marked him profoundly. After 1910 he exhibited regularly in the Salon des Indépendants and the Salon d'Automne. Archipenko was well represented in the Armory Show of 1913 in New York. During the war he worked in Nice, and between 1919 and 1921 travelled Europe with an exhibition of his work. His reputation in Germany and in America was assured in the course of 1921, and he settled in New York in 1923. Thereafter Archipenko was fully integrated into the American teaching system. His early works are in bronze, and move from the closely wrapped early forms (which are like Moore's early blocky 'primitive' pieces) to elongated stacked figures, made up of basic forms which appear to swivel out from a central core. An important step is made in 1913, when Archipenko uses planes to represent the extents and divisions of space, and his mature style is based on these two approaches, using both concave and convex, both form and void, to give a full sensation of the human figure. Relief plays an increasingly important part, while Archipenko is consistently faithful to the human figure, and, although less so, to the medium of bronze.

AVERY, Milton

b. New York State, 1925, d. New York 1965

pl. 75

Until his move to New York in 1925, Avery was essentially a manual worker who had only begun to draw after 1905 in evening classes at the Connecticut League of Art Students in Hartford. In New York he followed evening classes at the Art Students League until 1938. In 1927, at the age of 42, he participated for the first time in a New York exhibition. The turn of the decade marks a turn in his fortunes, as he begins to take prizes, and cements his friendship with Gottlieb, Rothko and Newman by vacationing with them. In 1935 he had first one-man show at the Valentine Gallery, and this gallery helped him to become familiar with the work of Matisse, as his next gallery, that of Paul Rosenberg, acquainted him with Picasso. His paintings become brighter, and the colours less naturalistic. Nevertheless, his interest in flat blocks of colour, and their boundaries and junctures is constant; as is his process of increasing simplification, working from sketches through watercolours and charcoal drafts to the final painting. The process was often lengthy; the sketches dating from summer holidays. After 1949 he suffered from increasing ill health, and his recent celebrity was eclipsed by the suddenly fashionable Abstract Expressionists. These were the artists to whom, ironically, Avery had been so important. Rothko spoke of 'this conviction of greatness' which 'was true for many of us who were younger, questioning and looking for an anchor'. In 1957, the critic and spokesman for the Abstract Expressionists, Clement Greenberg, admitted that he had previously not recognized Avery's significance.

BACON, Francis

b. Dublin 1909

pl. 81

At the age of 16 Bacon moved to London, and after beginning work as an interior designer, moved into painting, especially after seeing a Picasso exhibition in 1927-28. Bacon underwent no formal training, and was increasingly discouraged by his lack of success. In 1942 he destroyed much early work, and during the war was taken up by duties. Bacon has been consistently interested in subject and technique, and has never abandoned figurative art. His subject matter is frequently related to the great masters or to other visual quotations, and his style has been affected by his early knowledge of a book of X-Ray photography and of Muybridge's photos breaking up movement. The X-Ray manual recommends the positions of the body which allow the X-Ray to provide the maximum of information, and Bacon has used not only the ghostly effect of skin wrapped around armatures, but also these positions of maximum vulnerability. It is the vulnerability of the human figure: distorted, trapped, pinned down, revolving, melting or decomposing that has most affected Bacon's audience. It is possible then to see Bacon as a product of his time: of Surrealism and post-war existentialist anguish.

BELLOWS, George

b. Columbus, Ohio 1882, d. New York 1925

pl. 47

Bellows studied with William Merritt Chase, John Sloan and Robert Henri at the New York School of Art, and became one of Henri's circle. Bellows quickly took up the theme of the city for his paintings. He enjoyed early success and in 1908 became the youngest elected associate member of the National Academy of Design. Bellows was a member of the executive committee of the Association of American Painters and Sculptors, and for several years taught at the Arts Students League. Bellows never travelled to Europe. His tendency towards the monochrome is echoed in the 195 lithographs that he executed between 1916-1925. His depiction of urban America moves towards social commentary in his pictures of street scenes, prize fights, slums, prayer meetings and political events. The vigour of these paintings is quite different from the subtle and compassionate portraits executed in his last five years.

BONNARD, Pierre

b. Fontenay-aux-Roses, 1867, d. Le Cannet 1947

pl. 49, 50, 55, 65

After a traditional academic career, which culminated in a law degree, Bonnard entered the artistic world, and Sérusier's newly-formed group *The Nabis*. Until 1905, Bonnard was among the most modern painters and their experiments; they were overtaken (in the eyes of posterity, but also in their own) around that date by the Fauves and the Cubists. Bonnard began by combining decorative art with his painting; he designed posters, prints, magazine covers and theatre sets, and this flat graphism must have encouraged concurrent experiment in his painting. After 1906 he regularly exhibited at Durand-Ruel's gallery. His life was essentially regular; summer trips outside Paris which provided motifs for his paintings lengthened with time. In 1912, he bought a house at Veronnet near Monet's at Giverny, in 1925 he bought another in Le Cannet in the South of France. Although he is often associated with Mediterranean idylls: he was equally inspired by the very different, more changeable light of the Atlantic Coast. Interestingly in Bonnard's paintings Phillips found 'the "muffled radiance" we love so much in Chardin'. His constant companion, Marthe, is the subject of many paintings, and also of his photographs. In the last decades of his long life he was very much a recognized master in the French art world.

BRAQUE, Georges

b. Argenteuil 1882, d. Paris 1963

pl. 56, 57, 60, 61

Braque's father, a painter-decorator, moved to Le Havre in 1890, and Braque received an early training in this profession. At the age of 20 he began to take art classes in Paris, and by 1904 was confident enough to take a studio. His early friends are conspicuous as future members of the Paris avant-garde, and Braque was involved in the brief life of Fauvism. In 1906 he spent the winter at L'Estaque, a site made famous by Cézanne's pictorial experiments. The following year he met the dealer and future historian of cubism, Kahnweiler, there; and in Paris was much affected by a large retrospective exhibition devoted to Cézanne. After 1909 he became increasingly close to Picasso (whom he had met through Kahnweiler's friend, the poet Apollinaire), and he later described their cubist experimentation together as being like 'two mountaineers roped together'. This work was interrupted by the First World War. As success was secured, and regular contracts with art dealers assured the comforts of life after the war, Braque branched out into sculpture and set design. The period from the 20s is not marked by any great changes in Braque's life, but rather by consistent yet subtle innovation in his art. Cubism was tamed and refined; but still served as the underlying vocabulary. From the 40s Braque enjoyed increasing international success.

CÉZANNE, Paul

b. Aix-en-Provence 1839, d. 1906

pl. 19, 22, 28

His prosperous background allowed Cézanne the freedom to paint, which he took up full-time in 1862, and in 1886 he came into his inheritance. After an early period in and around Paris, where he had joined his school friend Zola, he was generally based in the South of France. He took part in the 1st and 3rd Impressionist exhibitions, and painted with Pissarro and Renoir. The dealer Vollard arranged his first one-man show for him in 1895, and another big exhibition in the year after his death affirmed his greatness. His painstaking analysis of nature; its breakdown and subsequent reconstruction, was extremely influential for young artists, and Cézanne, along with Van Gogh and Gauguin, has traditionally been considered to be one of the 'fathers' of modern art. His hesitative touch, seemingly visible on the canvas or paper, has brought the artist close to his viewers.

CHARDIN, Jean-Baptiste Siméon

b. Paris 1699, d. 1779

pl. 2

Chardin's artistic career was marked by constant residence in Paris (which he never left), regular attendance at the Royal Academy, and sustained, if modest, success with critics and collectors. Although he had not received sufficient education to allow him to tackle ambitious subjects, he enjoyed early renown as a talented painter of 'animals and fruits'. An English observer noted 'Chardin who paints little pieces of commonlife'. The French ambassador to Madrid was an early collector of Chardin's works, and artists, such as Delacroix, Ingres and Picasso are notable among later ones. Chardin was benevolently treated by the court; receiving annual pensions after 1752, and accommodation in the Louvre galleries after 1757. In 1755 he was made Treasurer to the Academy, and took responsibility for the arrangement of the pictures at their annual exhibitions. Chardin worked at perfecting his compositions on a limited repertoire of objects. After 1730 he began to paint kitchen scenes, and after a period of domestic interiors, he returned to still-lifes after 1748. The familiarity of these scenes and their objects is furthered because of the copies that Chardin made after his own paintings, and the many engravings. From 1771 he explored another medium with his pastel portraits. Chardin was soon forgotten after his death, and was only 'rediscovered' in the 1840s, since when he has been increasingly appreciated for his beautiful renditions of the everyday world.

Chase, William Merritt

b. Williamsburg, Indiana 1849, d. New York 1916

pl. 23

Chase was renowned as a dandy, who led an exotic lifestyle in the most coveted studio in New York. However, Duncan Phillips observed, 'He deserves to be long remembered for his influence upon the development of taste in the United States during the period when we were slowly acquiring some of the artistic sagacity of Europe'. By this, Phillips is referring to the great efforts Chase made in developing art teaching in America. He taught at the newly formed Arts Students League for nearly twenty years from its formation in 1878, founded his own New York School of Art, took summer schools to Europe, and furthered outdoor teaching at summer classes on Long Island. Although Chase, after his training in Munich, continued to spend a good deal of time in Europe, he nevertheless returned faithfully to America. On his trips abroad he met Sargent and Whistler, two of the artists he most admired, and to whom his style can be most readily compared. His familiarity with the European scene is confirmed by his exhibiting with *Les XX* in Brussels, and by his winning a medal at the Paris Universal Exhibition of 1889. He was a successful and stylish portrait painter, but it was his still-lifes (especially of fish) that were most prized by American museums. After 1885 his dramatically dark palette lightened with his experience of Impressionism and Long Island. He became known as the painter who revealed the charms of American parks. One of his pupils, Georgia O'Keeffe, said of him 'I had no desire to follow him, but he taught me a good deal'.

Corot, Jean-Baptiste-Camille

b. Paris 1796, d. 1875

pl. 4, 6, 13

After study in Paris. Corot went to Rome, where he was one of a group of French neo-classical landscape painters. He travelled around Italy for three years, returning to Paris in 1828. In the earlier part of his career Corot sketched from nature in summer, and over the winter worked his sketches up into finished paintings for exhibition. Only in 1849 did he dare to exhibit a study made directly after nature, and it was the sense of real contact with the outdoor landscape that attracted younger painters to Corot in later years, who saw in him a precursor of their own concerns. He made two shorter trips to Italy in 1834 and 1843, and the Tuscan landscapes of 1834 announce his Poussinesque period. In this period it was common for French painters to work in Italy, and one of the most famous precedents for this custom was Poussin. Corot's Italian pictures are associated with a blond palette and solid construction. Corot achieved recognition in the 40s: in 1840 the State made the first of several purchases for regional museums and in 1846 he was awarded the Légion d'Honneur. The 1855 Universal Exhibition sealed his fame, and the Emperor became a patron. His silvery, sylvan style of the 50s – associated with French, northern landscape in contradistinction to his earlier Italian style was very popular, but the figure paintings of the 60s were less so. The popularity of his feathery landscapes meant that his use of pupils to execute his work increased towards the end of his career.

COURBET, Gustave

b. Ornans 1819, d. La Tour de Peilz 1877

pl. 7, 8

Courbet arrived in Paris in 1839, where he studied and made copies in the museums after a wide range of pictures. By the mid-40s Courbet's ambition was emerging; he intended to paint large pictures and to be famous within five years, and in 1845 had his first submission accepted for exhibition by the Salon. 'This was one of only three acceptances out of 24 submissions 1841-47.' In 1849 he was more optimistic; 'I am on the point of being successful because I am in contact with some very influential people ... we are about to found a new school, of which I shall be the representative in painting.' This 'new school', was that of Realism, whose protagonists put forward new subjects for inclusion in artistic categories. By monumentalizing everyday life (and the everyday life of workers, country people, and the poor) Courbet disconcerted Salon audiences used to subjects that were obviously beautiful, classical or moral. Courbet's spectators found themselves uncertain how to read his pictures, for their meanings were not obvious. Courbet did not only paint 'social' pictures, but also landscapes, frequently inspired by his home countryside near the Swiss border, where he went annually during the shooting season. Although without any obvious social message, the landscapes were also painted in a vigorous, naturalistic style that suggested an unaffected honesty on the part of the artist. With the 1848 revolution in France, the Salon jury was abolished, and Courbet was able to exhibit ten pictures. This marked the beginning of the intertwining of Courbet's career with political upheavals in France, which eventually led to his flight to Switzerland in 1873. Courbet's success at the Salon depended on the regulations and the regime in power at any given period. In 1855 and 1867, on the occasion of International Exhibitions in Paris, Courbet organized large private exhibitions of his own work to offset official neglect. These attracted no more favourable reviews than his Salon submissions, although they set a precedent for such initiatives.

DAUMIER, Honoré

b. Marseilles 1808, d. Valmondoir 1879

pl. 9, 12

His father's ambitions brought the family to Paris in 1816, where Daumier helped to support the family as an errand boy. A piecemeal artistic training preceded and accompanied his apprenticeship to a lithography firm. Three years as a political caricaturist for the press culminated in a six-month prison sentence in 1832. After his release, the 1835 laws on the liberty of the press led him to abandon political satire for that of manners. He was active as an artist in both the 1848 and 1870 'revolutions': when brief heady moments appeared to promise a fuller role for the artist, and this involved fellowship with like-minded artists. Around 1848 he essayed more ambitious subjects, but thereafter increasingly used the theatre, public, transport, laundresses, lawyers, and art-collectors as themes. He was friendly with Delacroix, and the Barbizon group, and they helped to support him in the period in which *Charivari* did not take his lithographs. Although he would have preferred to paint full-time, financial pressure ensured his fidelity to the lithograph; he executed over 4,000 lithographs, but little more than 100 paintings. Nevertheless, they have been much appreciated, and Phillips considered him as 'perhaps the greatest artist of the Nineteenth Century'.

DAVIS, Stuart

b. Philadelphia 1892, d. New York 1964

pl. 58

Another student of Robert Henri, and close to the Realists of the Ashcan, school, Davis' work soon received an enormous stimulus from the Armory show, which he described as being, 'the greatest shock to me – the greatest single influence I have experienced in my work'. Davis turned to non-objective art as early as 1919. In the early 1920s he began to adopt the methods of Cubist collage, and this building up of flat planes from found objects influenced him to paint in a similar way. In 1927 he adapted the classical canon of cubist (or indeed any) still-life (the bottles, glasses and musical instruments) to modern American still-life, and painted an egg-beater, electric fan and rubber glove repeatedly for over a year. The bold, decorative mixture of flat coloured planes with straight coloured lines that he came to in these paintings is used again in his paintings of Paris streets, 1928-29. He explained, 'To many people a picture is a replica of a thing, or a story about some kind of situation. To an artist, on the other hand, it is an object which has been formed by an individual in response to emotional and intellectual needs. His purpose is never to counterfeit a subject but to develop a new subject'. In Paris he met Léger, whose mural work appears to have had an influence on Davis, Davis commented, 'Léger is the most American painter painting today'. During the 30s, involved in the Works Progress Administration, Davis had the chance to adapt his own scale to the mural. Jazz, which had always been important to his art, became more visible in the 40s; his paintings are busier and more jumpy. During the 50s Davis' work became ever bolder and simpler, although at the end of the decade he returned to a more detailed complexity.

DE LA FRESNAYE, Roger

b. Le Mans 1885, d. Grasse 1925

pl. 40

De La Fresnaye studied at the Paris Art School and at the Académie Ranson under Denis. He admired Puvis and Moreau, and around 1908-9 his paintings reveal the influence of Gauguin. After coming into contact with the cubist style he used it casually but lyrically to express the excitement of modern life. In 1912 and 1913 he participated in the Section d'Or exhibitions with other painters of the 'Cubist school' which never actually included Braque and Picasso although their influence was considerable. These Cubist 'followers' were more interested in subject matter than were Picasso and Braque, and used cubist style for a wider range of more traditional, allegorical or narrative subjects. They were also more concerned by the theory of cubism, and de La Fresnaye edited the avant-garde review *Montjoie!* in 1913, and after the war began to write about art. After 1920 he attempted to marry cubism with museum art, and a return to naturalism coincided with more human concerns in his painting. In this period he suffered from an illness contracted during the war, which led to paralysis in 1923, and his premature death in 1925. His painting career had, however, already ended in 1921.

DE STAËL, Nicolas

b. St. Petersburg 1914, d. Antibes 1955

pl. 82, 83

At the time of his 1952 London exhibition at the Matthiesen Gallery, many considered de Staël to be the most significant new painter to emerge in postwar Europe. Contemporaneously, however, his topicality was challenged by the emerging American school of Abstract Expressionism. Europe (and especially Paris) gave way to America, and de Staël might be seen as the last great painter of the Ecole de Paris. De Staël settled in Paris in 1943, and began to paint in a non-figurative idiom. Jeanne Bucher represented him in her gallery, and dealer-interest was not slow to emerge. In the 40s de Staël was painting in a cubist style, but after 1946 began to use rod-like lines alone, painted in thick impasto, to build up the picture. In 1949 the lines spread, becoming blocks, and concurrently his pictures became more restful. A 1951 exhibition in Paris of mosaics from Ravenna was an important stimulus which is visible in his work. In 1952 the visual excitement of a football match brought him back to figuration. De Staël also painted musicians, along with calmer pictures of bottles, apples and landscapes. In the early 50s, before his suicide, he attempted to render the Mediterranean coast, and the sense of light, solidity and space in landscape, with few, judiciously-placed blocks of colour. He frequently used a spatula to paint, but in his last year tried using brush and washes to render space.

DEGAS, Hilaire-Germain-Edgar

b. Paris, 1834, d. 1917

pl. 16

Degas was brought up in an educated and liberal atmosphere, and began to study law in 1852. His artistic interests were already accepted by his father, who allowed him a studio and lessons. In 1855 he entered art school (Ecole des Beaux Arts), but left the following year and went to Italy to study Renaissance painting. In 1858 he became acquainted with Japanese prints, and through this interest, met other like-minded artists. He met Manet in the Louvre in 1862. He had abandoned history painting for portraiture in 1865, but simultaneously began to look to contemporary life and entertainment for subject matter. In the 70s he exhibited with the Impressionists, and was regularly represented with them up to the eighth and last exhibition. After 1880 Degas began to etch, furthered his pastel work, and excelled in the monotype medium. He continued to use the female working world as subject matter; this time that of laundresses and milliners. As his eyesight deteriorated, he turned to pastels, and was increasingly cut-off from the outside world after 1893. It was in this period that Degas made his series of wax sculptures.

DELACROIX, Ferdinand-Victor-Eugène

b. nr Paris 1798, d. Paris 1863

pl. 10

Delacroix studied under Guerin at art school in Paris, and was very influenced by Géricault. His first Salon exhibit *Dante and Virgil* was bought by the State. Two years later, in 1824, he exhibited *The Massacre of Chios* which at once surpassed earlier attempts to treat in monumental form an incident from modern life. Delacroix continued to assert his modernity in deriving inspiration from other contemporary events, but another important source was Romantic literature and history. He used English sources (especially in the late 20s), notably Scott, Byron and Shakespeare, as well as being influenced by contemporary English painterliness. In 1832 he was greatly enthused by a visit to Morocco and Algiers, and surprised at the classical dignity of the people there. This trip was to provide source-material for many pictures. The governments of Louis Phillippe and Napoleon III favoured him with commissions for decorative schemes in several official buildings. These were carried out over twenty years, from 1833 to 1854. This was a great and unusual opportunity for monumental composition on a vast scale. Delacroix is equally arresting on a small, intimate scale; his drawings are masterpieces, although his importance is generally taken to be as a colourist. All his work is energetic, frequently turbulent: Romanticism as an attitude to life is taken to merge with Romanticism as an art form.

DERAIN, André

b. Chatou 1880, d. Garches 1954

pl. 59

Derain's later work has been overshadowed by the attention shown his Fauvist and Cubist periods. Yet, for nearly forty years from around 1915, Derain developed his own kind of realism, working from still-lifes, landscape, and the female model. Such realism has been judged old-fashioned, and this has tended to obscure Derain's fascinating, if arcane, erudition. Moreover, when juxtaposed with Picasso and Braque, Derain's realism has tended to be compared unfavourably. In his early years Derain was very close to Vlaminck, and they contributed to the Fauvist room at the 1905 salon. From 1909 he worked in close collaboration with poets, producing wood-engravings to accompany their work. After mobilization during the war, he worked on the first of several stage sets. The brilliant colour of his Fauve canvases is progressively subdued, and naturalistic colours are taken up: surfaces become glossier and more dramatic. Derain went on to become a successful society portraitist. After the Harlequin themes of the 20s, his subjects become more everyday, although more complicated readings frequently lie beneath the surface.

DIEBENKORN, Richard

b. Portland, Oregon 1922

pl. 89

Diebenkorn is very much a West Coast and a 'university' artist, who has been able to take advantage of a system of support unknown to the preceding generation. In the 40s and 50s the Phillips were unusual in being East Coast admirers; Diebenkorn was only familiar within California. The Phillips Collection had been an important stimulus to him when, enrolled in the Marine Corps, he was stationed in a base near Washington DC. By 1945 he was back west, where he attended the California School of Fine Arts in San Francisco. Paintings by Rothko and Gorky in the museum there were very important to him. Work done at the University of New Mexico (1950-52) is suggestive of maps, or aerial views of farmland, in its inter-locking, jig-saw like quality. (In 1970 Diebenkorn was among a group of artists asked to take aerial photographs of irrigation projects.) A 1952 Matisse retrospective in Los Angeles was an important stimulus. As Diebenkorn's 'abstract landscape' of the early 50s began to be recognized, he turned to figurative painting. His abstraction had been poised between painting and drawing, and his paintings of still-lifes and women echo similar concerns. Line is still important, and it becomes increasingly straight. Taut linear frameworks stretch across the canvas, table-tops tip sharply forward, figures hold the canvas together, flat across its surface. Similar construction, though drastically simplified, is visible in his 'Ocean Park' abstracts after 1968. Thin black lines now divided the coloured ground, forming envelope-like portions.

DOVE, Arthur G.

b. Canadaigua, New York 1880, d. Huntington, Long Island, New York 1946
pl. 69

Until well into the 20s Dove helped support himself with his work as illustrator and cartoonist. Between 1907 and 1909 he travelled through Europe. His *Abstractions* of 1910 were first exhibited at Steiglitz's '291' gallery, and though this links his name to the '291' group, his work is closer to, and contemporaneous with, that of Kandinsky. His next (and this time, one-man) show in 1912 at '291' highlighted his pastels, *The Ten Commandments*. In 1912 Dove moved to Westport, where he supported himself through farming. Apart from five years in New York in the 30s, Dove always lived apart from the city, living a secluded life. Around 1924 his second phase emerged, still dependent on the seminal 1912 series of pastels. The 'breeder idea' contained within this series was constantly important to Dove; it represented 'the Idea' of nature as a living force, brought out by organic forms and abstract style. By the 1920s Dove was deeply interested in theosophy, Eastern religions and occult literature. He began to experiment with collage; its textures and its satirical possibilities. Steiglitz was faithful to him as a dealer and confidant, and after 1930 Dove was also able to rely on a monthly grant made over to him by Duncan Phillips. Dove's work of the 30s, still abstract, is suggestive of nature in a metaphysical rather than a literal way. Dove always used nature as his primary source, and would then, as he put it, 'paint the part that goes to make the spirit of painting and leave out all that just makes tons and tons of art'. In the 40s his style became more geometric and rectilinear.

Dufy, Raoul

b. Le Havre 1877, d. Forcalquier 1953

pl. 66

In the Parisian ateliers where Dufy trained he came into contact with the other painters who were to be named the Fauves; the painters whose brilliant colours shocked visitors to the 1905 Salon: Friesz, Matisse, Rouault and Marquet. After a period of more restrained 'Cézannisme' and cubism, Dufy returned to his bright palette. His bold colour sense also lent itself to decorative work, and his designs for couturiers and silk-manufacturers were consistently popular. His style of overlaying large blocks of colour on an underlying linear framework adapted itself equally well to paintings, fabric printing and woodcuts (with which he illustrated several books). Indeed it seems likely that decorative and woodcut techniques helped form his mature painting style. Dufy was involved in the Paris exhibitions of 1925 and 1937; with 14 tapestries at the former, and his huge mural, *The Fairy of Electricity* for the Pavilion of Electricity at the latter. Dufy was a successful society painter, and found his subject matter in the elegant leisure world of casinos, regattas and race-courses. These subjects still allowed him to paint a life-long interest; the juncture between the interior and the exterior worlds. After 1947 his paintings became increasingly monochromatic.

El Greco, (Domenikos Theotokopoulos)

b. Candia, Crete c. 1540, d. Toledo 1614

pl. 1

It was natural for a native of Crete (a Venetian dominion) to seek further training in Venice, where 'the Greek' arrived c. 1564 and where he appears to have been a pupil of Titian. After his arrival in Rome in 1570, he became part of the humanist circle around Cardinal Farnese's librarian, Orsini. This assured El Greco's formation as a 'learned artist' of the late 16th century; and in Toledo, where he went in 1577, tempted by an important commission, he was part of an educated, legal and ecclesiastic elite. Toledo itself was Spain's most important ecclesiastical entity. This allowed El Greco to work for private religious institutions; and thus his religious paintings were assured of a learned audience. His formation must account for the elevated opinion he had of the artist's role, and may account for the five law-suits in which he was involved concerning his treatment as an artist. He worked only briefly for Philip II; the bulk of his paintings were commissioned for churches and hospitals in and around Toledo. In the first decade of the 17th century he developed as a portraitist.

FRANCIS, Sam

b. San Mateo, California 1923

pl. 88

Between 1943 and 1948 Francis suffered from spinal tuberculosis, which was caused by a crash as a fighter pilot. Obliged to convalesce lying on his back. Francis attributes his interest in painting to those years spent staring up into space. As he said of a later extended period in hospital (1961), 'In the hospital I was in love with things. I was a prisoner in love with the products of my imagination. So they appeared to me as things embedded in space. The space also was a thing'. Artist David Park's visits to the San Francisco hospital (during the 1943-48 confinement) must also have been important. After studying in Berkeley, Francis went to Paris, and has since enjoyed perhaps greater fame in Europe (and Japan) than in America. In the late 40s Francis covered his canvases with scrunchy, cell-like blobs, which, in the 50s, became softer in colour and more nebulous. There is frequently a feeling with Francis that we are looking through a microscope at cross sections cut out for slides, which is intensified by the liquid nature of his backgrounds. (This sensation is especially strong with his work of the 70s.) The 'Blue Balls' series dates from 1960, in which blue balls are on the edges of the canvas, as if pushed there by centrifugal force. In 1965 narrow ribbons replace the loose organic shapes, and Francis called these minimalist works his 'sail paintings'. His interest in Bonnard may well be relevant to Francis' centrifugal compositions. He has increasingly come to balance large areas of white with brilliant sections of colour. This is how he has established balance in the large areas of space in his mural compositions. Francis' interests in oriental art, the sky, and in primary colour enlivening a mass of white were neatly brought together in Japan in 1966 when he devised a sky painting show for helicopters.

GOYA Y LUCIENTES, Francisco José de

b. Saragossa 1746, d. Bordeaux 1828

pl. 3

Family contacts ensured Goya a position in the Royal Tapestry Factory. This, with several ecclesiastic commissions, accounted for Goya's time until he came into his own with his portraiture of the infant don Luis' family in 1783. On his appointment as Assistant Director at the Academy he came into contact with noble and commercial patrons. In 1786 he was named Painter to the King. In 1788 he painted the portraits of the new king Charles IV and his wife, and was then named *Pintor da Camara*. In 1792, afraid for himself and his Enlightenment colleagues, he escaped Madrid. On his return he became the Academy's Director, and his friendship with the Duke of Alba, and subsequently, his young widow, led into a period rich in portraiture, and more personal projects. Although still in court favour, for he was named *Primor Pintor* in 1799 and painted the portrait of the royal family, he worked increasingly for the aristocracy. During the Napoleonic invasion of Spain, Goya played a tactful waiting game, but later revealed his horror at the barbary he had witnessed in his etchings and two monumental paintings. His mood became increasingly sombre in his later years. With a renewed sense of political intimidation after 1823, he fled to France. His official, yet slightly precarious career is reflected in the variety of his output: majestic, realistic, charming, documentary, macabre or fantastic; all modes are squarely within his grasp.

GRAHAM, John

b. Kiev 1886, d. London 1961

pl. 54

Biographical information about Graham is uncertain, especially in his early years. He was born Ivan Gratianovitch Dombrowski in Kiev, and only arrived in the United States in 1920. He studied at the Arts Students League under John Sloan, and by the late 20s was living in Baltimore, supported by collectors such as Duncan Phillips and Claribel and Etta Cone. He continued to visit Europe, coming into contact with avant-garde artists, and collecting primitive art. He was very much a theoretician of modern art, and his book, *System and Dialectics of Art,* and his knowledge made a great impact on such friends as Gorky, de Kooning and David Smith. One of several one-man exhibitions was held at the Phillips Memorial Gallery in 1929. In the 40s the occult took over as his main interest, and with this he forsook his interest in the developments in modern art and his abstract style for an eccentric, classicizing style.

GRIS, Juan

b. Madrid, 1887, d. Boulogne-sur-Seine 1927

pl. 43

At 1919 Gris left Madrid for Paris, where it was natural for him to seek out Picasso. Gris was not party to the early cubism of Braque and Picasso, but was soon to make his own, very individual contribution. In 1924 he moved towards conceptual painting, describing the object as economically as possible. This means that Gris took up synthetic cubism without having been deeply involved in the earlier stage of analytic cubism, in which Picasso and Braque had sought to represent volume without the traditional use of light and shade. Now the relationship between the objects themselves takes precedence over the relationship between the painter and his subject. Cubism is increasingly concerned with abstraction and poetry, and Gris was particularly close to like-minded poets. Collage helped him to explore the use of flat planes, in which increasingly generalized objects are tightly locked into the picture. In 1913 he used very bright colour, subduing this in 1915-16 by breaking it into pointillist dots, which lend space to his paintings. Colour is used less descriptively; and the rhymes among objects provide the canvas's architecture. After 1916 he applies the same pictorial methods to paintings of women, and harlequins. In his short life Gris produced a body of work of sober classicism, and was an important theorist of cubism.

GUSTON, Philip

b. Montreal 1913, d. Woodstock, New York 1980

pl. 87

Guston was brought up mainly in California, and was introduced to art as a boy, as a means to help him recover from his father's suicide. At the Los Angeles Manual Arts High School he became friendly with Jackson Pollock. Between 1928 and 1934 he travelled America, studying art for himself, discovering renaissance painters, and in particular, Piero della Francesca. In 1932 he visited the studios of the Mexican muralists and these two very different sources confirmed his interest in large-scale mural work. Involved as a muralist in the 1930s on public schemes and in the Works Progress Administration, he was brought back into contact with various Abstract Expressionists who caused him to question his own priorities. Yet, ironically, it was not until he had again been stimulated by Italian art (this time Venetian colourism), that he took the decisive step into abstraction. Despite his abstract work of the 1950s and 1960s, Guston's work always had a sense of content, and in the 1970s he returned to figuration. This bold work in strong colour, which frequently represented objects that were full of presence but whose identity was unclear, has been important for younger artists of recent years involved in the New Figuration.

HARTLEY, Marsden

b. Lewiston, Maine, 1877, d. Ellsworth, Maine 1943

pl. 76

After studying in Cleveland, Hartley went to the Chase School in New York, where Chase was among his teachers. A reproduction of Segantini influenced him in his own renderings of the Maine mountains, and he is often categorized as a 'painter of mountains'. Ryder was his next important stimulus. Hartley had the same tendency as Ryder to centralize his paintings, never working from the edges, but building up in the centre. Between 1912 and 1915 he spent parts of four years in Berlin and France, and was very impressed by Courbet and Maillol. Contact with the *Blaue Reiter* in Munich led to his development of expressionist abstractions. In America he enjoyed the backing of Steiglitz from 1909, and regularly exhibited at '291'. Back in Europe in 1914-15 he turned towards geometric patterning, but in 1919 he abandoned abstraction for more representational work. In the 20s he increasingly devoted himself to landscape painting. However, there are still signs of his earlier simplification of the motif in these later landscapes. His paintings of the land, sea and sky are generally of New England, and in 1937 he moved to Maine. These canvases are dominated by massive volumes, strongly outlined. His bold still-lifes are in a similar style. Hartley was also a poet and critic, writing, notably, of his deep admiration for the watercolours of John Marin.

HOMER, Winslow

b. Boston 1836, d. Prout's Neck, Maine 1910

pl. 26

Homer is famous as a marine painter and watercolourist, although these were intersts that he only developed with time. As a young man he worked as an illustrator for magazines, producing images of the world of fashion, leisure and sport. After his move to New York in 1859, Homer began to illustrate topical events, and was briefly engaged recording the Civil War. War was of more lasting significance for his career as a painter, for his first oils date from 1862, and were all of war scenes. They do not, however, represent action and are not concerned with heroism. His 1866 oil *Prisoners from the Front* resulted in immediate fame and recognition by the Academy. Although he lived in New York for over twenty years, he never painted, and rarely illustrated city life. In 1874 he suddenly stopped work as an illustrator, and this was probably due to his recent serious interest in watercolour. Two seasons (1881-82) spent in Tynemouth, England appear to have opened his eyes to the sea, and thereafter it is his principal subject. Women and children, once so important as subjects, increasingly give way to the masculine world of work. At this time he also refined his craft as a watercolourist: his washes acquire body, and scraping produces highlights. He made his permanent home on the peninsula of Prout's Neck, on the Maine coast, in 1884. Two stays in Nassau and Cuba encouraged him to use the very brilliant colour which is a feature of his late watercolours. Fishing tips in the Adirondacks, Florida and Canada varied and strengthened the depiction of his central subject – water. Homer's watercolours are notably calm and restful: the central focus of human interest, within a background of dominant horizontals, makes for great equilibrium. Homer, though so solitary, enjoyed great esteem. He was unusually well represented at the Chicago World's Fair of 1893 with 15 works (while Ryder, the other marine painter, was not included), and after 1900 received many honours.

HOPPER, Edward

b. Nyack, New York 1882, d. New York 1967

pl. 77

His three early trips to Europe seem to have had little impact on Hopper, who remained thoroughly American in training and in choice of subject. He had studied under Henri at the New York School of Art 1900-1906. Until his first one-man show of 1920, Hopper was obliged to work as a commercial artist. He often used his etchings of 1915-23 as a source for his later paintings. He turned to oils after 1920, and also to watercolour after 1923. He used watercolour to record his summer travels, and their associations are very different to those evoked by his oil paintings, which are more complicated and less cheerful. Hopper had a strong grasp of architectonic masses, and this frequently works to isolate the figure, and emphasize his or her loneliness. Even when he paints couples, they appear to be alienated from each other. A pervading melancholy, present from about 1913, grows stronger through the years. Hopper paints the human being as part of, not as superior to, the environment, and his work is often thought to portray the human loneliness that is part of modern urban life. He places his characters outside the home, in public places such as restaurants, theatres, offices, and, frequently, hotels. This idea of travelling man (perhaps even displaced or homeless man) is developed in his paintings of railroads. Hopper also painted un-peopled, rural scenes, frequently by or on the sea. Seemingly straightforward depictions of ordinary houses strike an odd note in their very ordinariness, and central positioning on the canvas. Hopper tends to use strange viewpoints for his paintings; frequently very low or high. His colours are always rich. Hopper was a brilliant painter of different kinds of light; challenging himself to evoke different times of day. The suggestion of the pointlessness and non-communication within the scene depicted makes Hopper comparable to Surrealist painters, especially de Chirico. His watercolours never depict figures; most are of New England architecture; its lights and shadows. A retrospective in 1933 at the Museum of Modern Art helped to establish Hopper's status; his work anticipated both the Regionalist and urban realist schools of the 30s.

INGRES, Jean-Auguste-Dominique

b. Montauban 1780, d. Paris 1867

pl. 5

Ingres enjoyed an official career as a painter, in both Paris and Rome. He was first in Rome from 1806-20, after winning the Rome Scholarship, and secondly, from 1835-41, as Director of the French Academy there. Prior to this, in Paris, he was teacher, and vice-president of the Paris School of Art. On his return to Paris he became its president. His success was crowned in his lifetime by a personal retrospective within the 1855 Universal Exhibition in Paris. Despite his establishment position, Ingres has generally been noted for his eccentricities of style. He was a great portraitist (whether in pencil or paint), but worked on other themes too: ideal, religious, oriental, mythical. The theme of bathers is tackled regularly through his career. His works are characterized by an idiosyncratic and beguilingly arabesque line. Drawing, the 'probity of art', was considered by Ingres to be its essential basis.

KANDINSKY, Wassily

b. Moscow 1866, d. Paris 1944

pl. 39, 41

Until the age of thirty it appeared that Kandinsky would settle down to an academic career in Russia; instead he went to Munich in 1896 to study painting. Nevertheless his childhood in Russia was an extremely important source to Kandinsky as an artist; it had culminated in his experience of Monet in 1895. By 1901 Kandinsky had ceased formal study, and, tempted by avant-garde activity, formed an artists group called the Phalanx. His interest in Russian folklore and art harmonised with the contemporary German Jugendstil interest in alternative art traditions; naive, medieval or Oriental. To further his knowledge of art traditions, Kandinsky travelled extensively 1903-1908. In Paris between 1906-7 he saw the Fauves. Back in the village of Murnau outside Munich Kandinsky was able to make the decisive step, and, in progressively simplifying the landscape, arrive at expressionism. In 1909 he founded the NKVM (New Artists' Association) from which a splinter group formed the Blaue Reiter group in 1911. Der Blaue Reiter was significant for its interest in expressing a spiritual quality in art, in alternative art forms, in music, and for its publication *Der Blaue Reiter Almanach*. Although Kandinsky's art changed in style, as form took precedence over colour, and although he was to be important as a teacher in Moscow and at the Bauhaus, the Blaue Reiter concerns of 1910-11 can be seen to inform his entire career. The quest for a new subject matter based only on the artist's 'inner need' occupied Kandinsky's life.

Klee, Paul

b. Münchenbuchsee, Switzerland 1879, d. Muralto-Locarno 1940

pl. 64, 68, 70

Klee encountered Kandinsky's Blaue Reiter group in Munich in 1911, and for the first time, came into contact with artists who where in tune with his own ideas. Marc, with his interest in animals, was an obvious friend, while August Macke travelled with Klee to Tunisia. Klee lost both friends in the war. The Blaue Reiter group confirmed Klee's interest in the spiritual, in the artist's mission to recreate rather than to copy nature, and in the idea or pictorial correspondences for the inner world. Despite their common love for animals, Klee distinguished himself from Marc, who, he said, "is more human, he loves more warmly . . . He responds to animals as if they were human", whereas "In my work I do not belong to the species, but am a cosmic point of reference". Klee used animals, birds, insects and fishes to express a variety of feelings about the way the hierarchies in the world operate. He identified three paths – the optical, the earthly, and the cosmic – to the understanding of the object in nature. A tendency to move from a macroscopic to a microscopic view of the world is visible in his work between 1910 and the 1930s. There is a sense of natural order with Klee, in his use of rhythm, repetitive pattern, and (increasingly in the later 30s) runic-style pictograms. In 1920 Klee was appointed to teach art in the Bauhaus, and this forced him to clarify his own ideas, and led to the publication of several seminal pedagogical textbooks. In 1930 Klee was honoured by a retrospective at the Museum of Modern Art in New York, but in the later 30s was among the victims of the Nazi attack on modern art.

Knaths, Karl

b. Eau Claire, Wisconsin 1891, d. Hyanis, Massachusetts 1971

pl. 78

After studying at the Art Institute of Chicago, Knaths made his permanent home in the old art colony of Provincetown, Cape Cod. His retiring life there, interrupted by short visits to Washington, New York, allowed Knaths time for study and reflection. Of his study of the theories of Severini, Klee, Mondrian and Kandinsky, Severini's *From Cubism to Classicism* was the most important to him. His work is obviously informed by cubism in its planar quality, and is not unlike Mondrian's early cubist paintings. Knaths worked from similar motifs; many of his paintings are made up of sea, dunes and sky. With his faith in the concept of correspondences, that the outside world could be exactly reproduced through exact colour intervals, spatial proportions and music ratios, he proceeded methodically. He preselected his colours from a dyers' *Color Harmony Manual* (based on Ostwald's colour classification), and adhered rigorously to this selection once he had begun work. Knaths received little public recognition in the early years, but the great exception in this was Duncan Phillips, who was his principal collector by the mid-20s, and who acquired over 47 paintings. Between 1938 and 1950 Knaths taught winter courses in the Phillips Gallery Art School. Knaths' first one-man show was in 1929; in the 30s he was involved in the Works Progress Administration, and after 1945 was represented by the dealer Paul Rosenberg.

Kokoschka, Oskar

b. Pöchlarn, Austria 1866, d. Montreux 1980

pl. 62, 67

Kokoschka studied at the Vienna School of Arts and Crafts, during a period when Vienna was the centre of significant artistic developments. He found an early protector in the architect Adolf Loos. Early drawings were published in Herwarth Walden's avant-garde journal *Der Sturm*, and in 1910 Kokoschka moved to Berlin and worked on it full-time. *Der Sturm* was one of the first manifestations of how Expressionism aimed to touch all walks of life: and indeed Kokoschka also made significant contributions to Expressionism as a playwright, director and poster designer. In all modes his direct and often brutal appeal to the emotions offended traditional sensibilities. *Der Sturm* also organized international avant-garde exhibitions, where Kokoschka's work caught the eye of the wealthy gallery-owner Paul Cassirer, who exhibited his work, and made it possible for the artist to travel and to paint. Henceforth Kokoschka's artistic output was increasingly connected with travel; not only in landscapes, but also in the portraits of notable persons whom he met on his travels. In both genres Kokoschka worked, often distorting the subject to draw out the emotional association of place, or the 'inner man', while remaining faithful to exterior data. His febrile portraiture was popular and sought after by European society. Travel was also associated with flight, as for many Central Europeans in this period. Kokoschka's paintings were among the victims of Nazi purges of so-called 'degenerate art'. During the Second World War Kokoschka escaped to Britain. In 1950 he founded the *School of Seeing* which he ran in Salzburg for eleven summers, and in the 50s was also involved with set design.

Kuhn, Walt

b. New York 1877, d. 1949

pl. 63

Kuhn studied briefly in Paris, and then in Munich. He was back in New York by 1905, and took up again as a free-lance cartoonist. He continued his studies in America at the Artists' Sketch Class, and spent one winter at the New York School of Art. His long and influential friendship with Arthur Davies began around 1910. In 1911 Kuhn was one of four founders of the Association of American Painters and Sculptors, formed to organize a group show. They rented the 69th Regiment Armory for one month in February 1913, and in it arranged the legendary Armory show of 300 modern American and European artists. Kuhn and Davies had travelled around Europe in preparation for the exhibition, and Kuhn also spent time in Europe on behalf of the collector John Quinn, who backed the Armory show. Kuhn also adopted the role of artistic advisor to the collector Lillie Bliss and the gallery owner Mrs. Harriman. The latter connection allowed him to exhibit his own work and access to important patrons. Until 1925 Kuhn spent half the year as a visual consultant to such diverse clients as vaudeville acts and shipping companies. With the threat of a serious stomach ulcer that year, he decided to devote two years uniquely to painting. Kuhn's themes then emerged: showgirls, acrobats and clowns, along with landscapes and still-lifes. The themes, and some of their monumentality, are reminiscent of Picasso, but the heavy, traditional portrait style is especially close to Derain's mature manner. With this recent accession of artistic maturity, Kuhn felt ready for his first show, held in 1927. The 30's were increasingly productive. Portraits of show-business people at rest, dressed up yet not at work, inevitably have an air of melancholy, yet Kuhn's comments on such pictures are unemotional and formalistic. Of *Plumes* he wrote, 'think of a vase or bulb with a large, graceful flowering. Or think of a foundation with arching sprays of beautiful colour'.

LUKS, George

b. Williamsport 1866, d. New York 1933

pl. 45

Luks trained at the Pennsylvania Academy of Fine Arts, and in Düsseldorf and Paris. In Europe he concentrated on drawing rather than on painting, and this background was useful to him when he returned to New York for good in 1893 and became an illustrator for the *Philadelphia Press*. This newspaper, on which Stuart Davis's father was art editor, was an important focus for many of the emerging school of American painters. There Luks met Sloan, and others, who introduced him to Robert Henri, a formative influence. Luks covered the Spanish-American war in Cuba for the *Evening News*. In 1895 he began to paint scenes from New York street life, and Luks love for Frans Hals and other 17th century Dutch masters is visible in these paintings, as it is in his portraits. Luks had a colourful personality, often taken to typify the optimism of 20th century America, and he was certainly keen, with his Philadelphian artist friends, *The Eight*, to create a genuinely American school of painting independent of European academic styles.

MANET, Edouard

b. Paris 1832, d. 1883

pl. 11

Manet had a long, conventional art training, and studied museum paintings, using them as source material and quoting from them. In 1862 Manet showed *Musique aux Tuileries,* the first of his many paintings of life in the capital. At the same period Manet's paintings reveal another thematic strand: Spanish, sensual and private, painted in strong contrasts of light and dark. The most famous example of this theme is *Olympia* of 1863, which disconcerted contemporary audiences uncertain how to interpret it. Nudity was found to be even more provoking in *Le Déjeuner sur l'herbe* of the following year. It was in 1863 that the future impressionist group gathered round Manet and his canvases rejected by the Salon. In this decade Manet executed the bulk of his etchings, which generally draw from his paintings. In 1874 Manet turned down an invitation to participate in the exhibition that was later to be called the 'First Impressionist Exhibition', preferring to hold faith with the Salon. Nevertheless, Manet executed many works in this period in a fresh, Impressionistic *plein-air* style, reserving his older, flatter contrasting style for portraits and still-lifes. Although a retrospective was held in the Paris School of Art the year after his death, Manet's art was not accepted by the establishment until well into this century.

MARC, Franz

b. Munich 1880, d. Verdun 1916

pl. 42

Marc began his artistic studies at the Munich Academy. Between 1903 and 1907 he was deeply depressed, and produced very little although travelling widely. In 1905, after extended inactivity, he left Munich for the Bavarian Alps and began to sketch animals. The years of doubt and inactivity ended when he was stimulated by seeing the exhibition in Munich of Kandinsky's New Art Association (NKVM), Matisse and Gauguin shows, and meeting Macke. Marc suddenly infused his own work with colour, and his 1910 *Horse in Landscape* met with success. By 1911 his use of the animal as symbol was fixed. The second NKVM show included Fauvist and Cubist work, and in 1911 Marc became a member. He studied ethnographical collections so as to escape tired European culture: and this was relevant in his collaboration with Kandinsky on the *Blaue Reiter Almanach* of 1912. The spiritual side of Marc, a-wakened in him in the 19th century by Wagner and Nietzche, matured, and was worked out through the animal symbol. By the eve of the First World War, Marc seemed to have much of the prophet in him, and although he hoped that the war promised purification, he lost his life to it.

MARIN, John

b. Rutherford, New Jersey 1870, d. Addison, Maine 1953

pl. 51

Marin was slow to begin painting. He went to the Pennsylvania Academy at the age of 29, and travelled Europe between 1905 and 1910. In Europe he was affected by Whistler's art, and met the photographer Steichen, through whom he was able to exhibit at Steiglitz' gallery in New York in 1909. Steiglitz supported him from then on until his death in 1946. Back in New York Marin began by painting energetic watercolours of the growing city and this remained an important theme for him. In Steiglitz' gallery Marin had seen recent French paintings, including the Cubists, and he adopted a loose cubism in his own work. His urban paintings are always more agitated, more 'Futurist', than his coastal subjects, and critics who liked the latter often found the former hard to take. After 1912 Marin followed a seasonal pattern of spending the summer in the country and the winter in the city. In 1914 he discovered the coast of Maine, and after 1920 spent almost every summer there. In 1934 he bought property on Cape Split, and spent all his remaining summers there. After 1918 Marin worked increasingly in the studio. Around 1922 in Maine he began to 'frame' his water-colours with a kind of window-frame around the composition, and often pinned them down with angular strokes across their centres. In the 20s his work becomes more geometric and jazzily abstract. In the 30s Marin returned to oils, and used them increasingly, where previously his primary medium had been watercolour. Nevertheless, his oils developed out of his watercolour technique, using the white canvas as he had previously used the white of the paper, and establishing a tension with the flatness of the support. Marin had long enjoyed critical esteem, but in the 40s was revered as a 'living old master'.

MATISSE, Henri

b. Le Cateau 1869, d. Cimiez-Nice 1954

pl. 79

After passing law exams Matisse began studying painting in 1892 in the studio of Gustave Moreau and gradually developed a personal style evident in the neo-Impressionist work *Luxe, Calme et Volupté* shown in the 1905 Salon des Indépendants. That summer working at the port Collioure he and several others experimented with landscapes comprised of charged colours and short brush strokes, the effect described as wild or 'fauve'. By the end of the decade he had completed the grand works *Dance* and *Music* which reverberate with flat, pure colour and simple, primitive rhythms. Matisse was attracted by Islamic art and spent time in Tangier. After a period of austere painting in 1916-17 which showed Cubist influence his compositions became more domestic and decorative. In 1918 he made Nice his principal home. Throughout his career Matisse made sculpture and also magnificent drawings and book illustrations. Recovering from a major operation he began in 1943 composing illustrations to *Jazz* with cut and pasted paper. *Interior with Egyptian Curtain* is one of many paintings which contrast the natural world outside the window, which acts as frame, with the surface plane, here identified by the violently patterned cloth. It is generally agreed that Matisse and Picasso are the major painters of the twentieth century. Matisse turning away from direct reference to events and conflict: 'What I dream of is an art of balance, of purity and serenity, devoid of troubling or depressing subject matter, an art which could be for every mental work, for the businessman as well as the man of letter, for example, a soothing, calming influence on the mind, something like a good armchair which provides relaxation from physical fatigue'.

MIRÓ, Joan

b. Barcelona 1893, d. Palma de Mallorca 1983

pl. 80

Miró, like Picasso, spent much of his career in Paris, but to a greater extent than Picasso, retained close links with his homeland. He studied art in Barcelona. Between 1918 and 1922 he was learning the lessons of Cubism, yet maintaining an independent and even sceptical view point. He made his first trip to Paris in 1919, and was initially involved with Dada activity. In Montroig he painted very detailed landscapes which are ludicrously real: realism became surreal. The calligraphy of the mark on the surface already interested him at this period, and it was later to be of paramount importance. In Paris Miró was notable close to surrealist poets, and from 1923 he began to create his own landscapes (as they created poetry) which had little in common with the outside world. Men are reduced to identifying attributes: beards, moustaches and pipes. Miró continued to use snippets of vocabulary from the outside world to make up his increasingly abstract, but always very human, paintings. In 1924 Miró joined the Surrealist group, and the following year began his 'dream paintings'. These appeared un-premeditated, but were frequently carefully prepared, and involved the 'scattering' of signs over a monochromatic ground. In 1928 he made a series of paintings after Dutch masters, and in 1929 sought the 'murder of painting' through the agency of collage. The 30s see Miró's artistic maturity, and, in Spain during the war in the 40s, he experimented with pottery. As his fame increased. Miró was involved with large scale ceramics for monumental commissions, and with sculpture; while painting remained constantly important.

MODIGLIANI, Amedeo

b. Leghorn (Livorno), 1884, d. Paris 1920

pl. 44

Modigliani arrived in Paris in 1906 after travel (to recuperate from the ill-health which always troubled him) and studied in Florence and Venice. His short and ill-documented life has been subject to much myth-making, as his easily recognizable portrait style has been prey to much forgery. In 1907, a year after moving to Paris, he met a modest patron in Dr. Paul Alexandre, who encouraged him to exhibit in the Salon des Indépendants. Brancusi's friendship encouraged him to devote himself to sculpture after 1909, and from then until 1914 he painted few portraits, and exhibited only six until after 1917. The 1913 Nadelmann exhibition confirmed him in his sculpture. Brancusi's heads, and his own experience of direct carving, may well have influenced the simplification and linear bias of his portraits. In 1914 the dealer Paul Guillaume began to buy his paintings and procured a studio for him. In 1916 Zborowski became his dealer and gave him a regular allowance. Paintings from his first exhibition of the following year at Galerie Berthe Weill were confiscated on the grounds of obscenity and no paintings were sold. By 1916 Modigliani had arrived at the style which has become recognizable to us as 'Modigliani': a thick opaque surface bears the pyramidal shape of the sitter, placed frontally, topped by an oval head with crisply delineated features. The setting is always interior, the eyes are frequently unseeing. At the same time Modigliani began using the nude, and in these he sometimes rejected the vertical format for the horizontal. Their interest is essentially in the linear shape of the body against the background, and his portraits also became more linear, elongated, and stylized towards the end.

MONDRIAN, Piet

b. Amersfoort, 1872, d. New York 1944

pl. 53, 73

An overview of Mondrian's work shows how his later geometric abstract canvases grew out of his progressive simplification of the natural world, and especially of the dominant horizontals and verticals of the flat Dutch landscape. His spiritualism was also important in affirming his faith in the significance of the simplest shapes and primary colours. Equilibrium was important to him, and Mondrian limited himself to the right-angle, but equilibrium did not mean stasis, for he sought to represent a dynamic idea of continual movement. Cubism played a major role in his development (he was in Paris before the war), helping him to break down natural phenomena into their constituent parts. However Cubism did not go far enough towards 'pure plastics' for him. After the war he was one of the founder members of the de Stijl movement. Its manifesto, published in four languages, aimed at an international audience, and its Dutch founders spent much time in Paris in the 20s. In this period Mondrian's work is purified and the number of elements reduced. Only in America (where he spent his last years) does a sense of rhythm, inspired by jazz, invade his calm canvases. Mondrian lived as he painted, arranging his studios to work like his paintings, with large white spaces and occasional vibrations of colours, thereby stressing the importance of the role of the spectator.

MONET, Claude

b. Paris, 1840, d. Giverny 1926

pl. 31

Although born in Paris, Monet was brought up in Le Havre, where he was impressed by an early encounter with Boudin painting on the beach. Outdoor painting, for which the Impressionists became so famous, was rarely practised at this date. In Paris Monet trained in the same studio as Bazille, Renoir and Sisley, and with them made trips outside the capital to paint from nature. Monet, with other young painters, increasingly found his more adventurous canvases rejected from the official Salon exhibition, and this caused them to organize their own showing. At their first independent exhibition of 1874 they were called, among other intended insults, the 'Impressionists' and it was this name that stuck. Monet was not one of the most faithful contributors to the eight Impressionist shows. In 1877 he painted several versions of St. Lazare station, and thereafter working in series was an increasingly important procedure to him. From 1888 he worked through, and exhibited at Durand-Ruel, series of *Haystacks, Poplars, Rouen Cathedral,* and, of course, *Waterlilies.* Travel (made possible by financial security after 1881) also occasioned series: the view of the Thames from the Savoy Hotel in London begin in 1899, and St. Mark's in Venice where he went in 1908. In the later 80s, and particularly after he established himself permanently at Giverny in 1890, retouching was very important to Monet. Moreover, the earlier sketchiness for which he has become famous was frequently occasioned by financial pressure to produce quickly. Monet had always distinguished between sketches and paintings, and later became insistent that only with reflection could he tell whether or not a painting was finished. This meant that there were long intervals between painting and exhibiting; the paint became thicker, built up in layers. Monet explained, "I want to prevent people from seeing how it is done". Coastal views also make up an important part of his subject matter, and their diagonals reveal especially clearly the influence of the Japanese landscape prints that Monet loved to collect.

MONTICELLI, Adolphe

b. Marseilles, 1824, d. 1886

pl. 18

When Monticelli arrived in Paris in 1846, for the first of several stays, the *Rococo Revival* was burgeoning. This renewed taste for the painters of the 18th century, and for the scenes of light-hearted aristocratic pleasure-taking which they portrayed, affected Monticelli, and such *fêtes galantes* were to be an important part of his oeuvre. On his next trip to Paris, in 1856, he met the painter Diaz (b. 1807/8) who influenced Monticelli to shed his academic style. Diaz had come to Rococo imagery as an apprentice painting Louis XV-style porcelain, and Monticelli soon picked up his Rococo and Oriental themes. Monticelli spent most of the 60s in Paris, but the war of 1870-71 caused him to return to Marseilles for good. In Paris the new parks had confirmed his developing vision of the *fête galante* with their scenes of contemporary women at leisure in wooded settings. Monticelli's interest in his Southern roots was all the more significant in a period of renascent interest in Provençal language and custom. It is notable that Monticelli deliberately abandoned the capital to pass his mature, and most productive, years in the South. (In 15 years he produced over 2.000 pictures.) There he was occasionally joined on painting trips by Cézanne, while Van Gogh also associated the South with Monticelli, who was an important model for him, and whose pictures he collected. Monticelli can be seen as a bridge between 19th century Romantic interest in Watteau and the imaginary worlds of Symbolism. As his paint and glazes became thicker, he moved towards the latter. Although fantasy scenes make up over half his output, landscape was probably more important to him. He also painted portraits, still-lifes, and genre scenes. The British were early collectors, although they, like most Parisian critics, thought that the artist had peaked in the early 60s. His late, more extreme painterliness only won recognition after his death, notably at exhibitions in Scotland. In Paris he was finally honoured by a large retrospective in 1908 of the Salon d'Automne but shortly afterwards was seen as irrelevantly retrogade.

MORANDI, Giorgio

b. Bologna, 1890, d. 1964

pl. 84

After working in his father's office Morandi spent six years from 1907 at art school in Bologna. He was alerted to artistic developments through articles by Soffici in *La Voce,* and by the Biennale exhibitions in Venice. In 1914 he saw the *Futurist exhibition* in Florence, and allied himself to the group working out of Futurism, becoming friendly with Carra and De Chirico. He had works published in their reviews. *La Raccolta* and *Valori Plastici.* After cubist and then surrealist beginnings, Morandi's distinctive style had emerged by 1920. His still-life repertoire is constant: the objects are still, and locked into place in the heavy horizontal compositions. In 1921 a Valori Plastici exhibition took place at the Gallery of Modern Art, Berlin, with Carra, De Chirico, Martini, Melli, Morandi and Zadkine. In 1928 he first participated in a Venice Biennale. His etchings, with similar subject matters, make up an important part of his work.

MORISOT, Berthe

b. Bourges, 1841, d. Paris 1895

pl. 30

In 1852 Morisot's family moved to the suburb of Passy, on the west of Paris, and Morisot was to be based there for the rest of her life. Her father encouraged his daughters' artistic education, and artists frequented the house. Under Corot's tutorship which began in 1860, Morisot began to paint outdoors. She first exhibited at the Paris Salon in 1864, and went on to participate in seven of the eight Impressionist exhibitions. She saw herself as one of them, and took their setbacks and successes as her own. Her family was close to the Manets: in 1868 she posed for Manet's *Balcony,* and in 1874 married his brother Eugène. Morisot painted the suburbs, from a woman's experience of them, as places emptied of men during the day, and set apart from the working world of the city. The only man she painted was her husband, and then, only at play with their daughter. She painted middle-class women at leisure in the neighbouring Bois de Boulogne, her sisters pregnant, with their babies, playing with their children, or dressed to go out. Her models were in her immediate world, family or servants, familiar, not professional. The environment is always intimate; even though a woman's dress may suggest the public place, it is not represented in the picture.

O'KEEFFE, Georgia

b. Sun Prairie, Wisconsin, 1887, d. Sante Fe 1986

pl. 74

O'Keeffe studied in Chicago and New York. She worked first as a commercial artist, then as a teacher. She left teaching in 1918, and came to New York, where she became a member of the group sponsored by the photographer Steiglitz at his 291 gallery. In 1924 they were married. Before this, Arthur Dow had interested her in his study of oriental design principles, and she had begun to produce abstractions. O'Keeffe worked from the real (using natural objects like flowers, shells and pine-cones), but her close-up views frequently disorient the viewer into seeing her work as purely abstract. However her redefinition of space and scale, the domination of the canvas by originally tiny details, the primary consideration for pictorial construction – these concerns mean that O'Keeffe is indeed, first and foremost, an abstract painter. Her paintings frequently suggest sexual forms (especially female), though always deriving from inanimate phenomena. O'Keeffe painted skyscrapers in a Precisionist manner, and architecture was later important to her in a more fundamental way for her abstracts. Natural architecture was also an important stimulus, notably that of New Mexico, where she went annually after 1929, and where she settled in 1949. In the 40s her works display further abstraction; reducing, stretching and blowing-up of forms.

PICASSO, Pablo

b. Malaga, 1881, d. Mougins 1973

pl. 34, 35

After Spanish beginnings, when he was very much in the forefront of avant-garde artistic life in Barcelona, Picasso began to make frequent trips to Paris. These are the years of his Blue Period; by the time he definitively settled in Paris in 1904, he was embarking on his Rose Period. In the years up to *Les Demoiselles d'Avignon* of 1907 (taken to mark the beginnings of Cubism), Picasso was getting to know many important figures of the Paris avant-garde. Working through primitive and African sculpture, frequently on long summer trips, Picasso and Braque were able, by 1909, to define Cubism as a style. In 1912, after experiments with collage, they moved into a flatter, simpler synthetic cubism. In 1913 came his first large retrospective. From 1916 onwards Picasso became increasingly involved with High Society, and with stage design for Diaghilev and the Ballets Russes. Time spent with them in Italy appears to have paved the way to increasingly calm, classical monumentalism. From 1924 Picasso was ambivalently involved with Surrealism. In 1928 the Minotaur theme first appeared in his work; a period of political commitment commences in 1937 with his *Guernica* for the Spanish Pavilion at the Paris World's Fair and in 1944 he joined the French Communist Party. In the 40s Picasso experimented with lithographs and ceramics. The remaining years, though consistently fruitful and even prophetic for contemporory painting, are essentially marked by Picasso's mounting fame.

PRENDERGAST, Maurice

b. St. John's, Newfoundland 1858, d. New York 1924

pl. 52

Prendergast has been seen as the first American Modernist. He was certainly one of the first American artists to see Cézanne's work, and perhaps the only one to develop an original response to Impressionism. Although born in Canada, Prendergast was brought up in Boston from early infancy. He began to study art on his second trip to Paris in 1891, when he enrolled at the Académie Julian. Here he came into contact with contemporary British and French art, and was especially interested by the *Nabis*. Although Prendergast occasionally worked in oils, he is best known for his monotypes and watercolours. It was an exhibition of his watercolours in Boston that encouraged patrons to send him to Venice in 1898. The pageantry of Venice suited Prendergast's style, and he went on to take up similar scenes of leisure in America. In 1908 he exhibited with The Eight, but was poorly received. In all, Prendergast made seven trips to Europe. Later, he experimented with styles other than his usual mosaic-like dabs, and with new subjects such as nudes and still-lifes. In his last years he abandoned his dabs of colour for a broad, sweeping stroke. Duncan Phillips described Prendergast as a 'delightful decorator'. 'There was something primitive and Gothic about him. Living always with his brother Charles, a wood carver and craftsman of genius, their simple studio was a place of consecration to beauty'.

PUVIS DE CHAVANNES, Pierre

b. Lyons 1824, d. Paris 1898

pl. 14, 15

Puvis is famous for his murals in public buildings, and also as a slightly ambiguous talisman for a range of modernist artists: Picasso, Matisse, the Nabis, Redon, Seurat and Prendergast among them. Puvis is an isolated figure who fits into no immediate group; he can be, and has been, treated as a Symbolist, and as an Academic. The fact that he cannot be pinned down has made him all the more important as an influence on younger artists. Fresco, because a public art, was regarded by the 19th century critic as one in which the artist must act responsibly towards his audience. Puvis might design schemes of allegorical complexity (as in his murals for the Sorbonne University and the Paris Town Hall), but more characteristic are his schemes of narrative simplicity – immediately legible (and memorable) to any passer-by. He created group panoramas, with figures placed rhythmically across a landscape. His technique is calm and majestic, the murals unfold slowly, the wall is respected. Even his small easel paintings have a monumental quality, and it is notable that Puvis brought such an approach to easel painting at a time when the two forms were considered to be quite separate disciplines. Decorative needs encouraged Puvis to go outside the canons of academic art. Working on mural schemes over five decades, Puvis made his motifs flatter, abandoning chiaroscuro, increasingly concerned that the mural harmonise with the architecture and did not overshadow it. His preferred sacred themes of faith, purity, and moral solitude are reinforced by such a style. His murals were matt and light in tone, and although he explained that this was simply due to their particular environments, it means that the Phillips sketches are all the more striking in their warm bright colours. They were designed for the Museum at Marseilles, a scheme of the second decade of his career, after he had already worked on the Amiens Museum.

REDON, Odilon

b. Bordeaux 1840, d. Paris 1916

pl. 33

Although Redon had begun his artistic training in the mid 1860s, he considered that his originality appeared later – after the war of 1870. From this period date his early black works, and for two decades he worked only in black, in charcoal and in lithography. The first of many albums of lithographic prints, *In dream*, appeared in 1879. Redon began to make his mark as a purveyor of weird and memorable images. "All my originality consists then of making improbable beings come to life humanly according to the laws of the probable, putting, as far as possible, the logic of the visible at the service of the invisible". With the admiration of certain critics, notably Huysmans, in the mid 80s, Redon began to be classed as one of the 'Decadents'. Redon was sufficiently aware of contemporary literary and artistic cults to set his work within such contexts, but was later able to draw on them (for example, Wagner and Flaubert), in a more inspirational manner. The suggestiveness of his work meant that Redon could be placed in many contexts. His large 1894 exhibition at Durand-Ruel's revealed Redon working in colour, and though the blacks co-exist with his paintings and coloured pastels, they declined in number to disappear by 1900. At the same time the work's content shifts, moving from the monstrous to the serene. Around 1895 Redon went through a period of mystic spiritualism. Flowers became increasingly important as a subject after 1904. Such spiritualism, and his bright colour made Redon a natural ally for the Nabis and, later, the Fauves.

RENOIR, Pierre-Auguste

b. Limoges 1841, d. Cagnes 1919

pl. 20

Renoir's long life meant that he lived on to become the 'grand old man' of Impressionism well into the twentieth century, gaining in monumental stature. Although associated with rural idyll, he was brought up in Paris, where he became a porcelain painter. This art may account in some measure for the translucency of Renoir's canvases. Having saved his wages, Renoir entered Gleyre's studio where he met Monet, Bazille and Sisley. With them he painted in the Forest of Fontainebleau, and in 1868-69 Renoir painted boating parties on the Seine with Monet who influenced him. Renoir was never much inspired by the city of Paris itself, although he did paint women in fashionable urban interiors. Renoir's real subject, however, is the woman (and the girl), and the interest is in the fall of light, whether interior or exterior, on her skin and dress. Although an early contributor to the Impressionist exhibitions, he later sought the sanction of the official Salon, and was encouraged by his success there, and the commissions it brought him after 1881, After his time in Italy 1881-82, he moved away from Impressionist techniques, his colours became drier and more acidic, and line more important. Increasingly absent from Paris, he eventually settled in Cagnes, on the Côte d'Azur, a Mediterranean site that has been conflated with Renoir and his art; golden, harmonious, classical and timeless.

ROTHKO, Mark (Markus Rothkowitz)

b. Dvinsk, Russia 1903, d. New York 1970

pl. 85, 86

In 1913 Rothko arrived in New York, where, after 1924, he was to spend all his life. He followed classes at the Arts Students League and, in 1928, came to know Milton Avery. In the 30s he was active in New York artists' movements and in projects for the unemployed during the Depression. From 1935-7 he participated in the government funded Works Progress Administration, which gave many artists the backing and opportunities to create during the Depression in ways outside those available even normally. In the early 40s Rothko became concerned by the content of painting; exploring mythical and Christian themes. He was interested in his readings of Jung, and also Nietzsche. Although his painting quickly became abstract after this period, its subject was still important to Rothko. He insisted that his works were not simply decorative, and their content can be understood as Rothko reaches for the sublime, and becomes increasingly sombre after the later 50s. Understanding – akin to religious experience – was all-important; Rothko refused to explain his work after 1949. He was extremely exacting on hanging and lighting conditions; when he felt them to be inadequate, he might withdraw his work. As one of the newly titled 'New York School' (1949), he was among those Abstract Expressionists who enjoyed real celebrity from the 1950s, and was involved on several prestigious mural schemes.

ROUAULT, Georges

b. Paris 1871, d. 1958

pl. 71

Rouault began his working life as an apprentice stained glass-maker, and this is not surprising in view of the style of his paintings, with their heavy black outlines and thick blocks of colour. Rouault was especially impressed by copies of medieval windows in his workroom. He took evening classes at the School of Decorative Arts, and in 1890, enrolled full-time in the Paris School of Art. Matisse and Marquet were among the fellow students who benefitted from Moreau's teaching there. Affected by Moreau's death in 1898, Rouault went on to become the first curator of the Gustave Moreau Museum (in 1903). Rouault is more of a lone figure than many of the contemporary avant-garde; he did not enjoy the close working relationship experienced by various Fauves and Cubists, nor the advantages of a dealer or a patron's interest. In 1901 he retreated briefly to a Benedictine fellowship outside Paris led by Huysmans (also a great admirer of Moreau). Back in Paris, Rouault spent the next decade depicting modern society and its victims. His themes – the circus, the law-court – are reminiscent of Daumier's, but their characters are bolder and coarser, definitely survivors. Perhaps because of the unpopularity of his paintings, Rouault turned to ceramics, lithography and etching around 1910. This work turned out to be so well received that, ironically, it further contributed to the neglect of his paintings. Indeed, Rouault's relationship with printmaking was never entirely happy. Before he could afford oil and canvas, Rouault worked in mixed media on paper. In 1913 the dealer Vollard bought his entire previous production, and between 1917 and 1939, shielded him from material care. After 1914 Rouault's themes became more interiorized; melancholy is not only religious, but also tragi-comic, and creeps into old subjects, such as that of the circus clown.

Rousseau, Henri

b. Laval 1844, d. Paris 1910

pl. 36

Rousseau is commonly called 'le Douanier', or the customs man, although he never in fact reached such heights in his work as a clerk in the toll houses around Paris. He began to paint around 1885, and although his superiors were tolerant, he took early retirement in 1893 to devote himself to art. After 1885 he regularly exhibited at the Salon des Indépendants. Rousseau was fiercely proud of his status as 'artist', and it is not clear to what extent he set his un-tutored art apart from the Paris art world. Before 1902 he mainly produced landscapes; but gradually added other themes: the jungle (first exhibited in 1891) full length portraits, occasional flower stud-ies, and group occasions. This last category frequently takes on a noble, allegorical stance; an indication that Rousseau was thoroughly aware of contemporary hierarchies of painting, and keen to take on the 'masters' at their own level. What is certain is that many contemporary artists admired him, and Rousseau was an important totem for the avant garde. In 1908 Picasso organized the celebrated banquet in his honour; Picasso and Apollinaire sought his company. The young playwright Alfred Jarry, also a native of Laval, consecrated Rousseau in print with an article in the *Mercure de France*.

Roussel, Ker-Xavier

b. Chêne 1867, d. l'Etang-la-Ville 1944

pl. 32

Roussel was a member of the Nabis. A life-long friend of Bonnard and Vuillard (whose brother-in-law he later became), he was inex-tricably linked with the work of these artists, although he never joined the more revolutionary aspects of Nabis theories.

In the early years the three friends shared studio space, exhibited together at *La Revue Blanche* in 1893, and produced colour litho-graphs for Ambroise Vollard in 1889. These lithographs gave a new definition and importance to the medium, fusing the tradition of Japanese woodcuts with Post-Impressionist composition and pic-torial space, and with the patterned planes of the Nabis. Through-out his career, Roussel would remain interested in the graphic arts, eventually gaining considerable renown as a printmaker.

From 1909 to the later years of his artistic career, Roussel received commissions to paint numerous decorative schemes, such as theatre sets and curtains, wall panels (Kunst Museum, Winther-thur, 1918), and the entrance hall decorations for the Théatre de Chaillot (1937), which he painted together with his friends Bon-nard and Vuillard.

Roussel first exhibited in 1901 at the Salon des Indépendants, and while his early paintings show the influence of the academic tradition and of Gauguin and his circle, Roussel's decorative work gradually lightened in colour and evolved in a technique reminis-cent of late Impressionism – bathed in the arcadian light of the Mediterranean.

RYDER, Albert Pinkham

b. New Bedford, Massachusetts 1847, d. Long Island 1917

pl. 27

Ryder was solitary, romantic painter, who had little formal artistic education, and received little public attention during his lifetime. He began by painting landscapes, often including a single animal. His pastoral poetry is somewhat akin to that of Samuel Palmer; his landscapes are more than just landscapes, and exude a sense of enigmatic significance or melancholy. After 1870 he lived in New York, and although he made several trips to Europe, he was notably unimpressed by European art, old or new. In 1877 Ryder was one of 22 founder members of the Society of American Artists, with whom he exhibited from 1878 to 1887. In the 80s he used literary sources as inspiration for his paintings: the Bible, Chaucer, Shakespeare, 19th century Romantics, Classical myth, and Wagner. However, although his landscapes are now peopled, they retain their earlier solemn qualities, and evoke similar sensations. After his early years he seldom painted directly from nature, although he loved to observe it, memorably on his night walks around New York and New Jersey. His oeuvre is small (around 160 paintings), and he developed concepts and paintings slowly, often working on them over many years. His unstable methods and mediums have resulted in the deterioration of many works. His late fame, and importance to younger artists, meant that he was included in the Armory Show of 1913, and that many forgeries (especially of his sea-scapes) were executed in his style. In recent years Ryder has been a hero to many contemporary painters, including Hartley and Jensen.

SCHWITTERS, Kurt

b. Hannover 1887, d. Ambleside 1948

pl. 48

When Schwitters began working in an abstract idiom, he sought a name for his work. In 1919 one of his assemblages featured the word Merz across its surface (all that remained visible from a Kommerz und Privatbank poster) and Schwitters used this name for his work thereafter. It is useful in signifying his idiosyncratic mixture of collage and painting. His assemblages have a durable feel, built up in many layers, combining paper and heavier materials. Pieces of rubbish are held together with a painterly overlay, Schwitters was one of the first artists, after the Cubists, to use rubbish in his work. In 1919 he was a founder member of the Dada group in Hannover, although the care that Schwitters devoted to the aesthetic qualities of his Merz pictures resulted in a slightly uneasy relationship with the Dadaists, who aimed to sabotage such criteria. Using rubbish was dadaist, but the way Schwitters used it was not always. Schwitters was also involved in the 'literary' side of Dada, writing, publishing, and composing avant-garde poetry. When Dada split into two groups in 1923; one political, one aesthetic, Schwitters went with the latter, more constructivist wing, which included van Doesburg of de Stijl. There is a constructivist element in Schwitters' work, with its use of geometric shapes (especially the circle and triangle) and its sense of balance. After his first visit to Norway in 1929, there is an increasingly naturalistic strand in Schwitters's oeuvre. In Germany, with Nazi seizure of power, Schwitters' freedom of action was increasingly limited and his works branded as degenerate. In 1937 he moved to Norway. After fleeing to Britain in 1940, he spent 17 months in an internment camp, but was able to paint there. Retiring to the Lake District, and supported by a Fellowship Award from the New York Museum of Modern Art, Schwitters set to work on the last of his three large-scale Merz constructions: the Merz barn, its completion interrupted by his death in 1948.

SCULLY, Sean

b. Dublin 1945

pl. 92

Scully's family moved to London in 1949. Apprenticed at fifteen to a graphic designer, he began formal training at Croydon College of Art and continued at Newcastle University. His interest in minimal American paintings, especially the work of Brice Marden and Robert Ryman, was confirmed during a period on the Knox Scholarship at Harvard University. In 1974 Scully decided to live permanently in New York. During the 1970s his hard-edge grid paintings gradually evolved into works comprised entirely of horizontal shapes. Since 1982 Scully has combined several panels in one work, of varying widths and colours, and frequently abutted at differing depths. These rugged works, with glowing but often sombre colours, are inspired by literary and historical sources. Scully explains his outlook is romantic "I've tried to make my paintings moving, powerful, and necessary, but to give them a kind of nobility – a physical strength so that they are proud of who they are . . .". He has shown extensively in Europe and America and in 1989 will have a major exhibition at the Whitechapel Art Gallery which will tour to Madrid and Munich.

SEURAT, Georges

b. Paris 1859, d. 1891

pl. 21

Seurat briefly attended art school in Paris before his military service. After his return to Paris he studied scientific colour theories; notably of Chevreul. In 1883 and 1884 his works were refused at the Salon, but in 1884 he was able to exhibit *Bathing at Ashières* at the new Salon des Indépendants. In 1885 the Neo-Impressionist group (as it was later known) of Seurat, Signac, Cross, Luce and Pissaro was formed. Basing their painting style on contemporary theories about colour, they used small touches of paint whose colours fuse at a distance. Seurat made monumental compositions about the Sunday pleasures of the newly industrialized Parisian population. In 1885 the group dispersed after Pissaro's departure. With his brilliant sense of colour, dividing colours into their tonal opposites, Seurat was able to transmit the sensation of bright light and deep shadow. This is particularly clear in his beautiful colour sketches. He liked to paint water, and painted (in more sombre Northern tones) the coastal towns on the Channel. He applied the same techniques to painting nudes, music-hall and circus scenes, in which a certain humorous tendency to caricature is belied by the overall sobriety of composition.

SISLEY, Alfred

b. Paris 1839, d. Moret-sur-Loing 1899

pl. 17

Sisley lived and painted on the Seine, to the north-west and the south-east of Paris, never far from the capital. He is the painter of the area's rivers and canals, bridges and roads. He painted winter, snow and leafless trees. A curving path often leads the viewer into the picture, which is rarely populated by more than a single figure. Sisley painted series of pictures from the same motif, such as the church at Moret where he settled in 1880. The generally horizontal bias to his canvas emits a sense of great calm and stability, heightened by his undramatic colours. After comfortable beginnings, Sisley was forced to support himself with his painting after his father's business failed in 1870. He had started painting, though more casually, in the early 60s, and in 1863 began working outside directly from nature. In 1872 Durand-Ruel began to buy several canvases a month. In 1874 Sisley was among the 'Impressionists' at the exhibition which won them their name. Even the interest of a dealer such as Durand-Ruel failed to gain him real support, and Sisley never enjoyed the commercial success experienced by Monet and Renoir. Only with the foundation of a new exhibiting Salon, the Societé Nationale, in 1890, did Sisley enjoy a measure of recognition, although his personal exhibitions were never successful.

SLOAN, John

b. Lock Haven, Pennsylvania 1871, d. Hanover, New Hampshire 1951

pl. 37

Sloan was brought up in the world of printing and illustrating. He taught himself etching, and became a master in this art. He found early success between 1894 and 1896 with his 'poster style': the fashionable graphic style of the period, akin to that of Alphonse Mucha. After 1891 he worked on the art staff of various newspapers and periodicals, beginning to paint in 1896. The artist Robert Henri was a formative influence on Sloan, stirring his interest in city life as subject matter, and introducing him to the work of Whistler and Manet. His work of this period is also reminiscent of Sickert. Sloan exhibited for the first time in 1900: he was the slowest of the 'Henri' group to arrive. After 1900 he also found work as an illustrator, thus affirming his reputation as an etcher. Having decided to go freelance as an illustrator, he moved to New York in 1904. He worked on prints of city life, whose subjects are often akin to those of Daumier, and after 1906, began to paint them. The 'Henri' group crystallized with the exhibition by 'The Eight' in the Macbeth Gallery in 1908. With this, the 1910 'Independent Artists' and the 1913 Armory show. Sloan found himself among the progressive secessionists, who had taken such action because they were frequently excluded from the National Academy's exhibitions. Sloan continued to work as a graphic artist, for various socialist papers between 1908 and 1913, and then for *The Masses* until 1916, when he left the Socialist party. In 1912 he returned to painting with renewed vigour, and the Armory show of the following year was a stimulus. In 1916 Sloan had his first one-man show at Mrs. H.P. Whitney's studio, found a sympathetic dealer in Kraushaar and began to teach at the Arts Students League. The Sloan studio enjoyed great renown there in the 20s. In the early 1930s Sloan taught briefly at Archipenko's art school. The 1920s see Sloan introducing very bright colours and nudes into his paintings, which makes them reminiscent of Matthew Smith. In 1929 begin the small hatched striations across the painting's surface, which became a trademark. After 1919 Sloan spent most summers in New Mexico, and enjoyed increasing celebrity in the 40s.

SOUTINE, Chaim

b. Smilovitchi, near Minsk in Lithuania 1893, d. Paris 1943

pl. 72

After two years' art study in Vilna, Soutine arrived in Paris and made his friends among the avant-garde, especially its immigrant fringes. Modigliani, a closer friend, introduced him to his own dealer Zborowski, but with limited results. Soutine only began to enjoy real financial security with the advent of collector Albert Barnes in 1923. The physical presence of the motif was vital to Soutine's inspiration; even when working after old-master paintings (Courbet, Chardin, Rembrandt) he had to recreate them in the flesh. Soutine's range was wide; encompassing portraits, still-lifes and landscape. By the early 20s his still-life subjects were fixed: fish or meat, subjects which were increasingly isolated on the canvas as the 20s advanced. With the influence of Rembrandt around 1924, the motif was centralised, and the style more modelled. Although Soutine is well-known for his paintings of gory carcasses of meat, landscape occupies the largest proportion of his oeuvre. It is in landscape that Soutine's two 'manners' can be measured: the close-up, lurching canvases of Ceret, and the later, airier, more spacious landscapes begun in Cagnes. (The Cagnes manner is also taken to include portraits and still-lifes.) The change occurred around 1923, and thereafter Soutine despised his earlier manner. In the 30s and 40s Soutine painted landscapes of the north rather than of the south of France. He was especially close to the countryside around Paris when, as a Jew, he was forced to leave the occupied capital. Later in his life Soutine drew important lessons from Corot and Courbet, admiring the sensation of immediate contact with nature that he found in both. Such immediacy is certainly characteristic of Soutine's style, and Modigliani compared his own hallucinatory states with Soutine's paintings: 'Everything dances around me, as in a landscape by Soutine'.

STELLA, Frank

b. Malden, Massachusetts 1936

pl. 90

Stella attended painting classes run by the historian of Abstract Expressionism, William Seitz, while reading history at Princeton University. After graduating in 1958, Stella moved to New York and encountered Jasper Johns' work. His early work, the 'Black' paintings, must have been influenced by Johns' use of repetition and monochromatic colour. From the beginning Stella has explored the relationship between the support (the canvas) and what is on it. He has identified his ideal as 'non-relational' painting. His work has moved outwards from the canvas, and become increasingly colourful. The paintings, which are now more like reliefs, or sculptures, invade the spectator's space. In the 60s Stella used metallic paints, and frequently included identation and cutting-away. He has continued to use similar methods and materials, and their hardness and glitter increase this impact, and emphasize that these paintings are more than just paintings. Such games played with the very nature of painting owe much, and make many references to, earlier twentieth-century movements like Cubism and Surrealism. Stella, who now lives in New York, is represented in many of the major museum collections of the world, and his work has been frequently exhibited.

UTRILLO, Maurice

b. Paris 1883, d. Dax Landes 1955

pl. 38

Utrillo was the son of painter Suzanne Valadon, who urged him to paint to combat his alcoholism. Nevertheless his alcoholism resulted in several stays in the sanatorium. From 1903 to 1905 Utrillo worked from life, and his subject matter – the drab world of the Parisian suburbs, frequently empty, with little sign of human activity – remained constant throughout his career. Impressionism affected his style between 1905 and 1907. Thereafter it became increasingly white and chalky. Indeed, he sometimes used plaster to thicken his paint. In this period Utrillo worked from memory, or from postcards, in artificial light. After c. 1915 Utrillo returned to a full use of colour, and figures began to appear in his cityscapes. Apart from two journeys to Corsica and Brittany, Utrillo remained faithful to Montmartre. In later years Utrillo had financial backing, and with improving health, was increasingly concerned with construction and technique. He represented France at the Venice Biennale in 1950. Despite (or because of) growing commercial success, Utrillo has not generally been included in conventional histories of modern art.

VAN GOGH, Vincent

b. Zundert, Holland 1853, d. Auvers-sur-Oise 1890

pl. 24, 25

Not until he was 27 did Van Gogh begin to draw; previously he had worked for an art dealer (for whom his brother Theo continued to work) and as a lay preacher. His brief art training was haphazard. In Nuenen, where his father had become pastor, he sketched weavers and peasants. The *Potato Eaters* was painted there, just after his father's death. By 1886 Van Gogh was in Paris, where he was to be fully integrated into the Parisian art world, and able to develop his recent discovery of Japanese art. In 1888 he went south to Arles, where he was later joined by Gauguin. After Gauguin's departure Van Gogh spent two weeks in hospital, and the following Spring, agreed to move into the nearby asylum at Saint-Rémy. In 1889 he set out for Auvers, near Paris, where he spent his last days before shooting himself in July 1890. From 1886 we can see Van Gogh using more expressive, less mimetic styles, building up the picture with tiny strokes. The following year the strokes are longer; their strong directional movements create a great sense of depth in the picture. Flat surfaces, and serpentine lines which divide the canvas are added to these strokes in the course of 1888. Despite his short painting career, Van Gogh was prolific, and managed to make statements with many different kinds of landscapes.

VUILLARD, Edouard

b. Cuiseaux, Saône-et-Loire 1868, d. La Baule 1940

pl. 29

Vuillard was successful as a young painter in the 1890s, but after 1905 his art seemed less and less *topical*, and by 1914 he had almost completely withdrawn from exhibitions. Only after 1938, when the public were able to see a large retrospective of his work, and especially the large decorative panels that he had executed for private houses, did Vuillard again receive critical interest. His early career was to some extent determined by the friends he made at school; Roussel and Maurice Denis with whom he went on, with Bonnard and others, to form the artists group the Nabis. The Nabis were influenced by, and worked through Gauguin's recent pictorial developments. In these years, as a symbolist painter, Vuillard was involved in the increasingly wide role of art which was no longer limited to oil painting. He received the first of many commissions for interior decoration in 1892: Vuillard was able to work both very small and very large, keeping his surfaces flat and matt, creating linear curves across the canvas, rather than allowing a sense of depth to lead a spectator in. By the early 90s Vuillard had esablished the 'intimate' style of portraits within interiors for which he is loved. Busy patterns knit different parts of the picture together; the people in the room are no more and no less important than its wallpaper and decorative textures. The Nabis had disbanded by 1900, and Vuillard moved increasingly in more fashionable circles, approaching a much glossier form of society portraiture by the end of his life.

WALKER, John

b. Birmingham 1939

pl. 91

Five years after leaving Birmingham College of Art in 1960 John Walker began showing large impressive abstract paintings. They were distinctive for the literal feeling of the shapes introduced into the colour fields. Several such as the trapezoid, a circle with wedge removed and a truncated oval, have re-appeared in various guises over a twenty-year period. Walker has consistently attempted a synthesis of abstract and traditional painting. The collage paintings of the late seventies were achieved with an original combination of gels, chalk and layered surfaces. In the 1980s the richly coloured Alba series used a standing form which made reference to Velasquez's duchess and to the illusionistic spaces of old master paintings. However, in the last few years the tones have been more austere and with greater emphasis on surface. Since 1970 when he was awarded a Harkness Fellowship Walker has worked mainly in the United States and was accorded the unusual honour of two one-person exhibitions at The Phillips Collection in 1978 and 1982. He has also spent considerable time in Australia and in 1985 the Hayward Gallery showed paintings from his Alba and Oceania series, 1979-84.